Doodle Art Drawing

Let Your Imagination Doodle Amazing Things Around You

By Mia Coulter

Copyright©2016 by Mia Coulter
All Rights Reserved

Copyright © 2016 by Mia Coulter

All rights reserved. No part of this publication may be reproduced, distributed, or transmitted in any form or by any means, including photocopying, recording, or other electronic or mechanical methods, without the prior written permission of the author, except in the case of brief quotations embodied in critical reviews and certain other noncommercial uses permitted by copyright law.

Table of Contents

Introduction	5
Part 1 Basics of Doodling	7
Chapter 1 How to Learn Doodling	7
Part 2 Drawings	16
Chapter 1 The Clock	16
Chapter 1 Aladdin's lamp	27
Chapter 3 The Wonder Woman- Thyia	41
Chapter 4 Piggy bank	55
Chapter 5 The Fox	69
Chapter 6 The Penguin	82
Conclusion	94

Disclaimer

While all attempts have been made to verify the information provided in this book, the author does assume any responsibility for errors, omissions, or contrary interpretations of the subject matter contained within. The information provided in this book is for educational and entertainment purposes only. The reader is responsible for his or her own actions and the author does not accept any responsibilities for any liabilities or damages, real or perceived, resulting from the use of this information.

The trademarks that are used are without any consent, and the publication of the trademark is without permission or backing by the trademark owner. All trademarks and brands within this book are for clarifying purposes only and are the owned by the owners themselves, not affiliated with this document.

Introduction

If you look at doodles closely, you will find that they have an inherent beauty, which depicts the mind of the artist. Other paintings are drawn consciously and hence; do not depict an artist's viewpoint as beautifully as doodles do. Doodles are drawn with subconscious mind; they are not filtered according to the suggestions of the world. When you are doodling, you are working to the tunes of your own thoughts. You are completely away from the disturbances of the outside world.

A world of doodles is the artist's own world. They do not have to worry about what people will think of their creations. No one is going to judge their doodles. Therefore, the result is much more beautiful than a well thought painting.

You must have seen kids or people doodling in movies, when a lecture or a meeting is going on. They are often misrepresented. Even though it is true that they are missing a part of meeting or lecture, but at the same time, they are creating something wonderful on the last page of their notebook. That last page is often the starting page of careers of many wonderful artists.

Many artists are there, who started doodling as just a past time, but discovered that they have a beautiful hand at doodling. They can create much more than they thought was possible. It has often been observed that doodling gives a kick-start to your imagination. You do not have to be very creative to start doodling. Creativity can come later. The important part is to pick up a pen and a paper and just begin doodling.

The first step is often difficult to take. You might think that you are not good at drawing, but you are forgetting that doodling is not an exam to pass. No one is there to judge you when you are doodling. It is only you, who can witness the results. It is all up to you whether and when you want to take suggestions from others. If you feel too shy in the initial phase, you can keep working and not show it to anyone else. When you feel confident, only then you can take suggestions from artists that are more refined.

This book, **Doodle Art Drawing: Let your Imagination Doodle Amazing Things around you,** is meant to let you get started with doodling. The first part will enlighten you about the basics of doodling and about how you can gather motivation for the same. In the second part, you will find illustrations of doodling, which will serve as a starting point for you. You can take off your journey from here on your own.

Good luck for doodling your beautiful world of doodles!

Part 1 Basics of Doodling

Chapter 1 How to Learn Doodling

Are you also among those who stand at fault for doodling during lectures or meetings? Doodling nowadays has become tantamount with daydreaming, at least the movies and TV shows depict it like that. It may seem negative according to the perception created by the movies, but that is not the case. You miss the details of a lecture or meeting you are attending but there are several other plus sides of doodling. As you doodle, you do it with your semi-conscious mind. The semi-conscious brain accesses the most creative side and then you come out with excellent ideas for the most troublesome issues.

Creativity has no limit for doodlers. Nowadays, you can see doodling getting so famous around the world that it has attained an entirely new genre called doodle art.

Doodling for learners

You might have been inspired by the doodles flooding all over the Internet. Many artists, especially beginners, want to try doodling but do not know where to start. This chapter is meant to give you a starting point for doodling beginners. Many kinds of doodling are becoming popular such as Zentangling, tangling, StenDoodling, doodles, etc. These sub-genres are enough to confuse you. You cannot stop yourself from doodling once you start it. You must have done it in your lifetime once or more whether or not you realize it. From the tips given below, you can encourage the practice of doodling:

Things you need

You need some basic things to start professional doodling:

- Copic Multiliners in different colors and sizes
- Copic Markers, grey, in different sizes- T0, T5, T1, T3, or C0, C5, C1, C3, etc.
- Blending Card XPressIt
- Open design rubber stamps
- Open design stencils
- Magazine, drawn or photo image
- Pencil

- Highlighter
- Ink Pen
- Charcoal
- Marker
- Ballpoint pen
- Chalk
- Pastels
- Coloured Pencils
- Paint
-

What you can doodle

You can doodle literally anything- yes, anything. You can start drawing floral patterns, circles, or lines. If you do not find these designs interesting, you can explore new shapes. You can use the stencils to copy patterns onto the blending cards. Take your favorite pen and fill the designs of your choice inside or outside these patterns.

Take inspiration

Whenever you feel like doodling, do not think anything else, and just start doodling. Whatever comes to your mind- an act, a feeling, an event, a person, a song, a place, your own surname, or anything else- do not wait for any other inspiration. Just start doodling. Do not let your feeling for doodling pass, unless you are not in a proper situation to doodle.

Sometimes, you can feel motivated after you start doodling. You do not always need a feeling to enlighten you to start doodling.

Free association

There is no limit to associating yourself with things for doodling. For beginning, you can take inspirations from flowers, names, etc. However, it becomes essential to find association in many things beyond normal vision. Find out patterns online, things that used to exist in the Victorian Era, etc. You will find that you have started developing out of the box thinking. Do not think that you have to get your work approved from someone. No one is there to judge you.

Doodle flowers

The most popular thing in the doodle genre is flowers since they are found in abundant variety and are fun to draw. You can use these tips to draw flowers:

- Draw a flowerpot and fill your favorite flowers in it.
- Draw flowers in a garden and draw sunlight falling on them.
- Write something with alphabets constructed in flowers.

Doodle faces

It is a little difficult to draw faces than flowers, but you will find great satisfaction when you draw faces. To begin with, you can start drawing the face of a friend, teacher, classmate, or just any random face. Use these tips to attain perfection in drawing faces:

- Draw one face expressing different feelings. This will assist you recognize the face muscles and how they change when the expressions change.

- Recall the face you are familiar with, and try drawing it. Then, you can compare it with the actual picture.

- Fill up a page with only one part of the face, such as eyeballs, with different expressions.

- Try drawing caricatures with different exaggerated expressions.

Doodle names

Write your own name and exaggerate its loops. Write it using very small alphabets, but do not compromise on legibility. Write it in big blocks of letters and design the clocks with stars, hearts, vines, and hearts. You can give any many shapes to the alphabets as you want.

Doodle animals

You can continuously fill the pages of your drawing book with scary or cute creatures. Begin drawing with your own pet or that of your neighbor. You can also imagine and create your own animal.

- Draw underwater creatures in the ocean of your own imagination.
- Doodle creatures from jungles such as parakeets, snakes, monkeys, leopard, elephants, etc.
- Transform any animal into a scary monster by adding evil eyes, fangs, horns, etc to them.
- Create a hybrid animal or bird. Mix the features of an animal with a bird.

Doodle whatever comes in front of you

Whatever you see in front of you- an old man, a stone, a kettle- you can open them down to your drawing book. The originality of these things can be given a fancy shape and you can also demonize them. Using simple objects, you can also create your own world of fairy tales.

Draw what you listen to

When you are listening to a teacher or you are in a meeting, but you are not interested, you can draw whatever you listen. For instance, if your teacher is talking about a historical person, say, Nelson Mandela, you can draw him using your own imagination. If your friends are gossiping about a person you have not met, draw them using your creativity. When someone says a word, such as, Bluetooth, draw it whatever comes to your mind, not the actual shape of it.

Draw a cityscape

Utilize the bottom and top margins of your notebook and fill them up with cityscapes. Draw the night scene of a city, half lit windows of houses, trees, lamps, trashcans, phone booths, dogs walking with their masters, etc. You can give a completely new shape to your own city.

Create a new world of doodles

When you become more familiar with creating new things, you can create an entire new world of doodles. Add your own imaginary animals, buildings, people, trees, things to this world. As the time passes, your drawings and doodles start adopting a unique style and anyone can recognize them as your signature doodles.

Part 2 Drawings

Chapter 1 The Clock

Clock is the last thing you want to see when you wake up in the morning. It reminds you that you have to rush to school, college, or work. Whatever the reason may be, hardly anyone loves to see an alarm clock in the morning. However, as the day passes, you start working according to the ticking of a clock.

Apart from its functional uses, a clock forms a beautiful subject for drawing and doodling. Here, you can use this alarm clock as the first subject of your doodling.

Step 1

Draw the basic outline of a traditional alarm clock in pencil consisting of two bells and stands. You do not need to draw the numbers in the clock face.

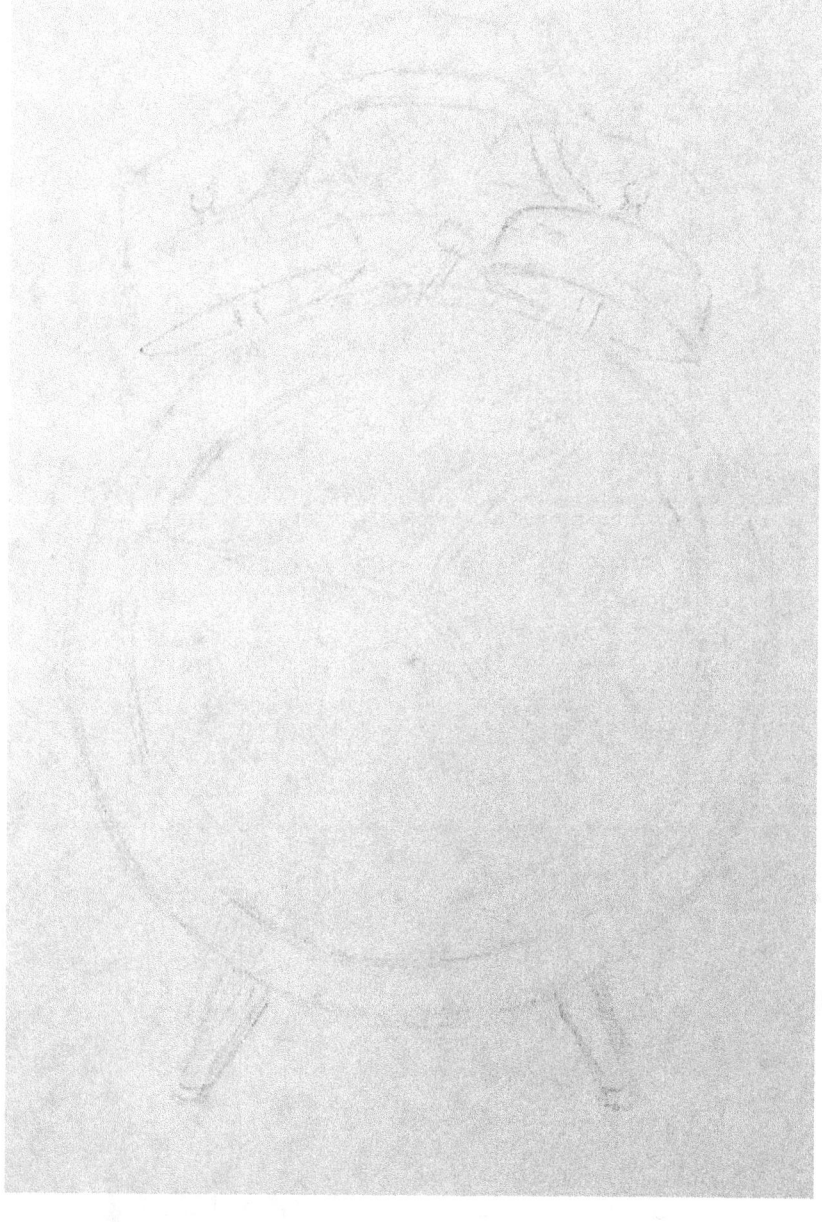

Step 2

Give final touch to the outline using an ink pen. Draw the second hand, minute hand, and hour hand of the clock.

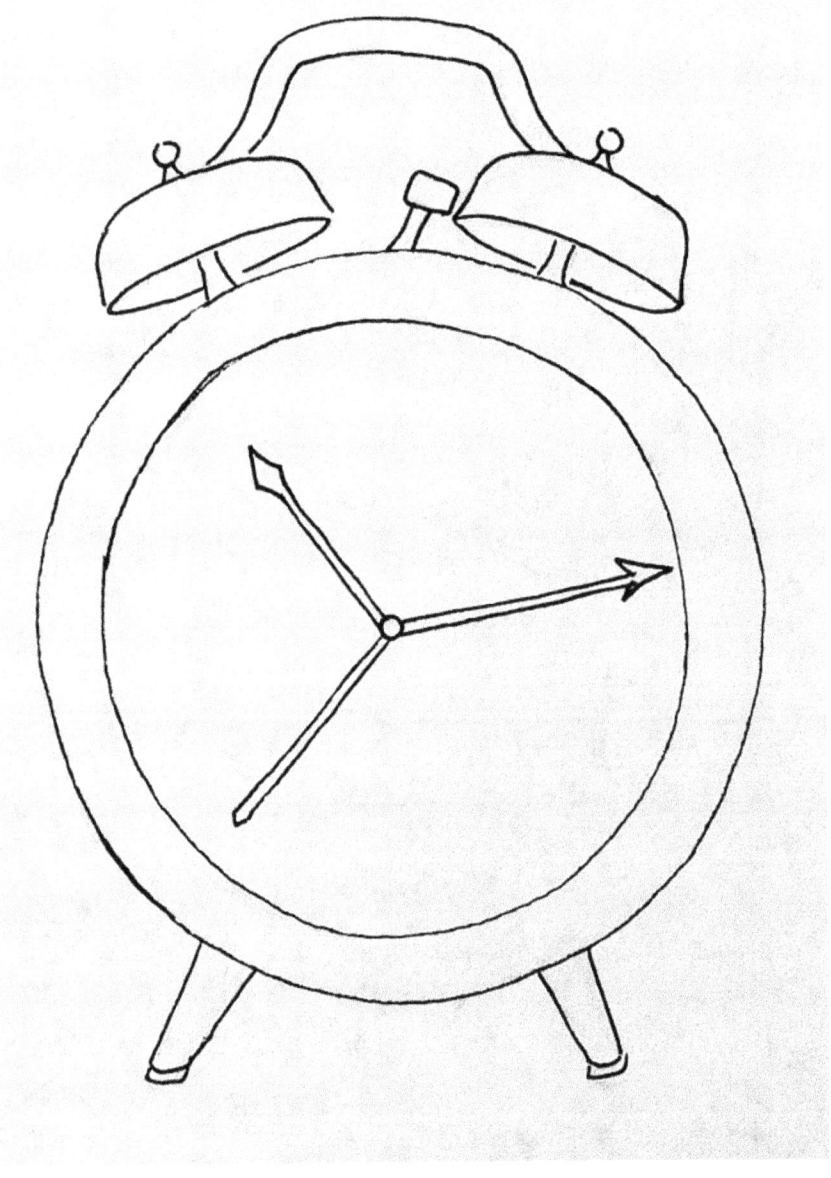

Step 3

Give shadows in the bells, thicken the outline of the hands of the clock, and thicken the top antennas of the bells. Thicken the base of the clock's feet.

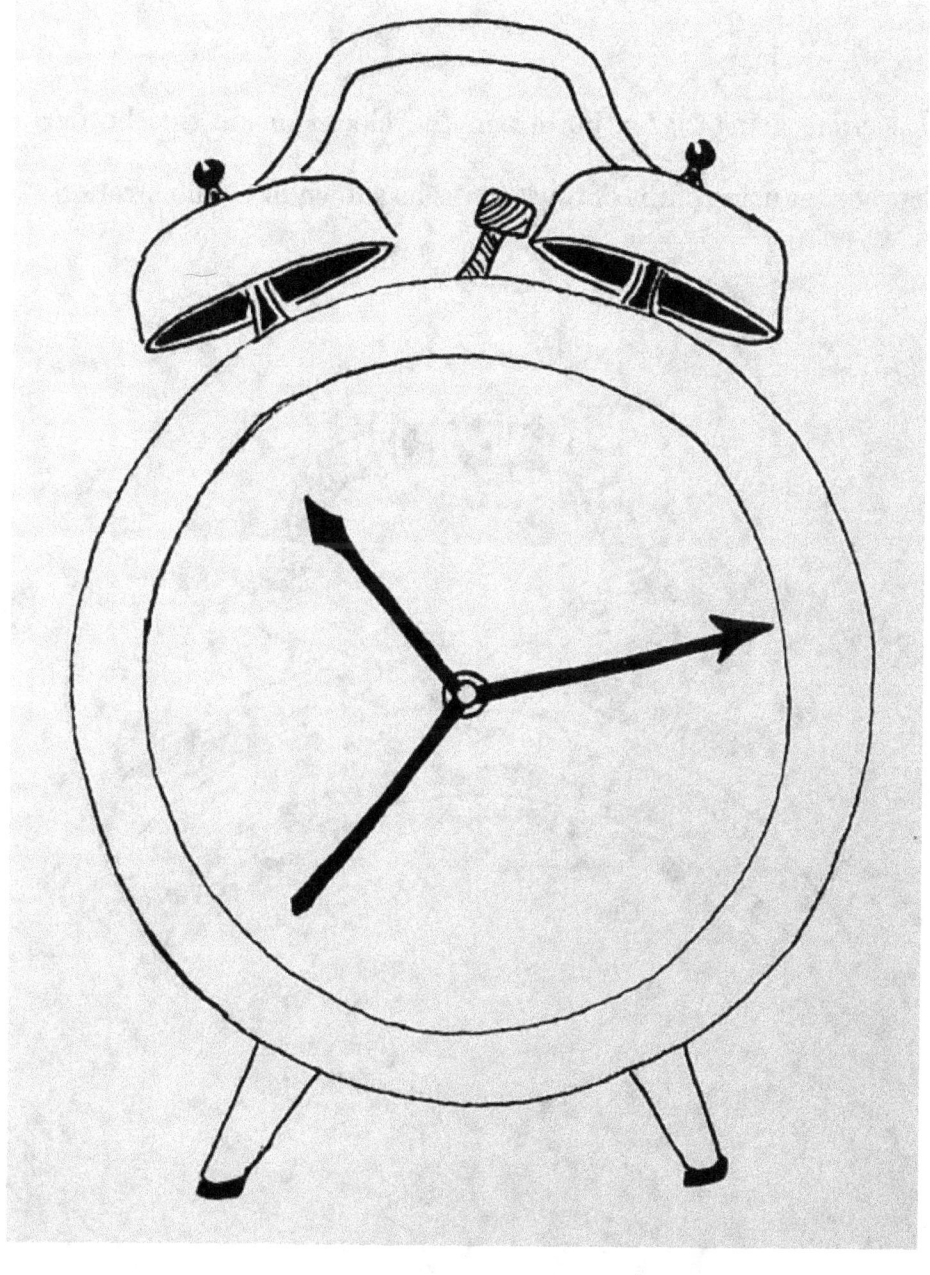

Step 4

Fill the connector shaft of the bells with vertical lines- thick and thin. Insert zigzag lines in between them. Insert hexagons and *- shapes in the left bell. Draw circles and diagonal lines in the right bell.

Draw a circle using zigzag border in the clock. Inside this border, draw another border using chips of thick strips as shown in the illustration.

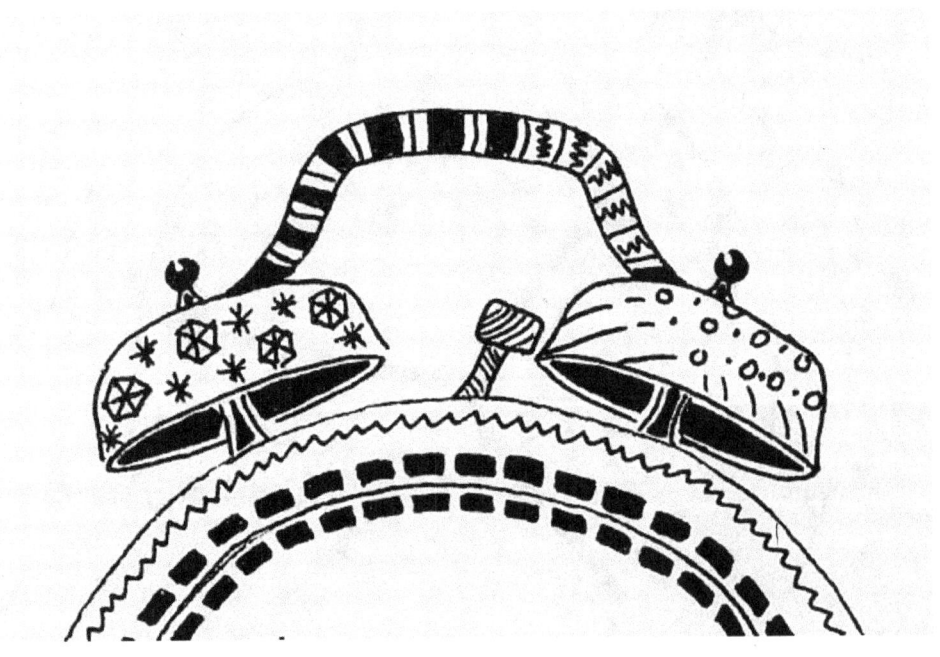

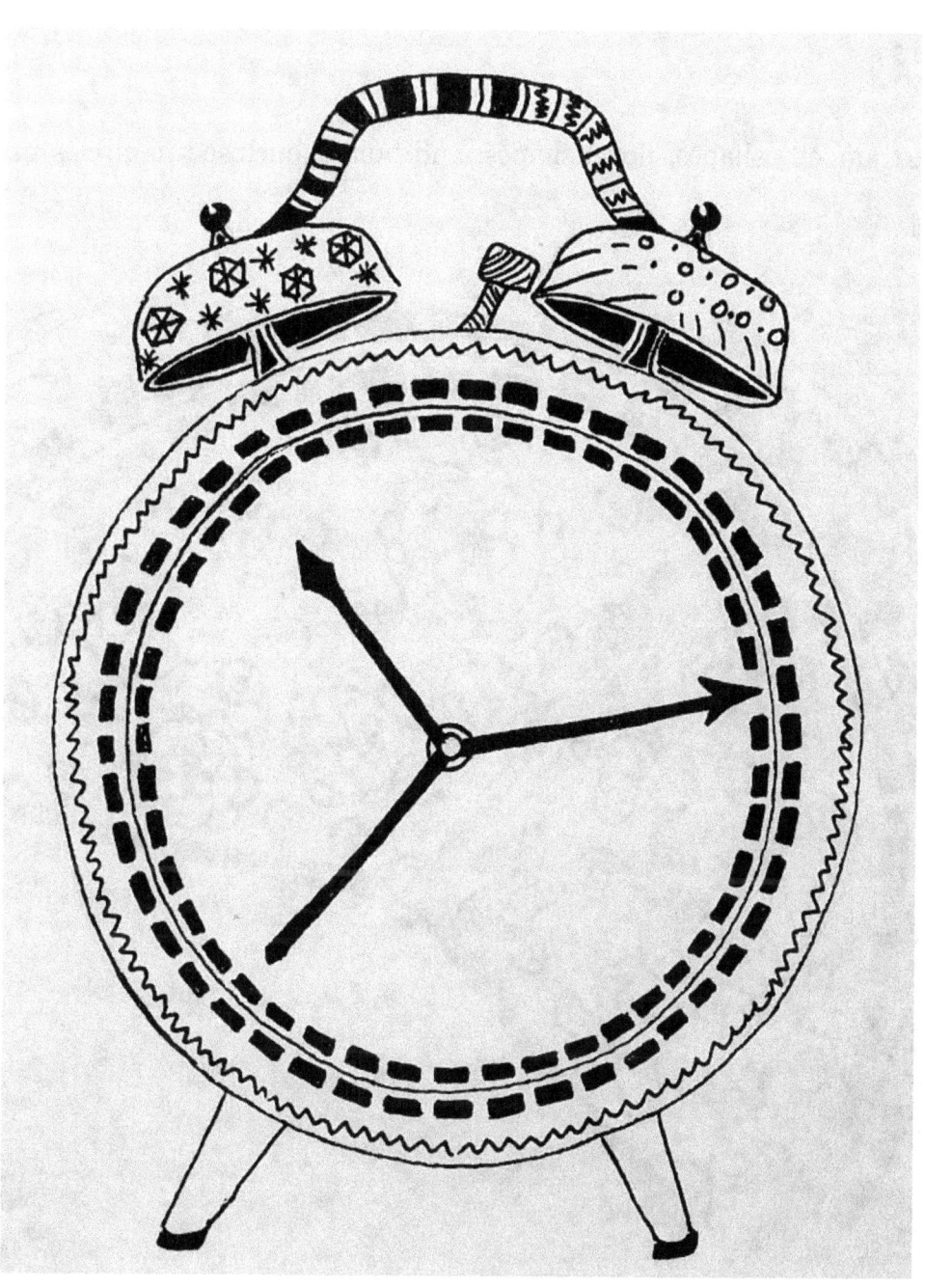

Step 5

Insert amoeba shapes, floral shapes, and bullets enclosed in circles in the clock.

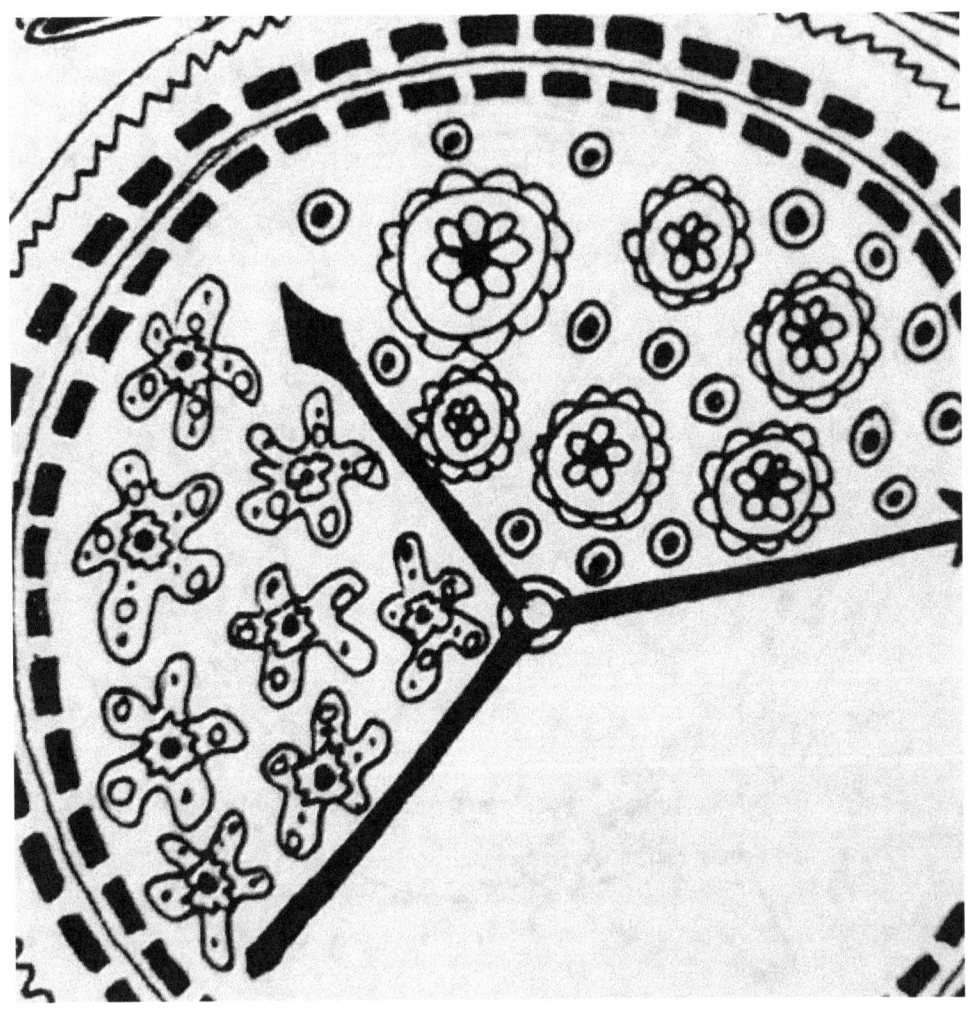

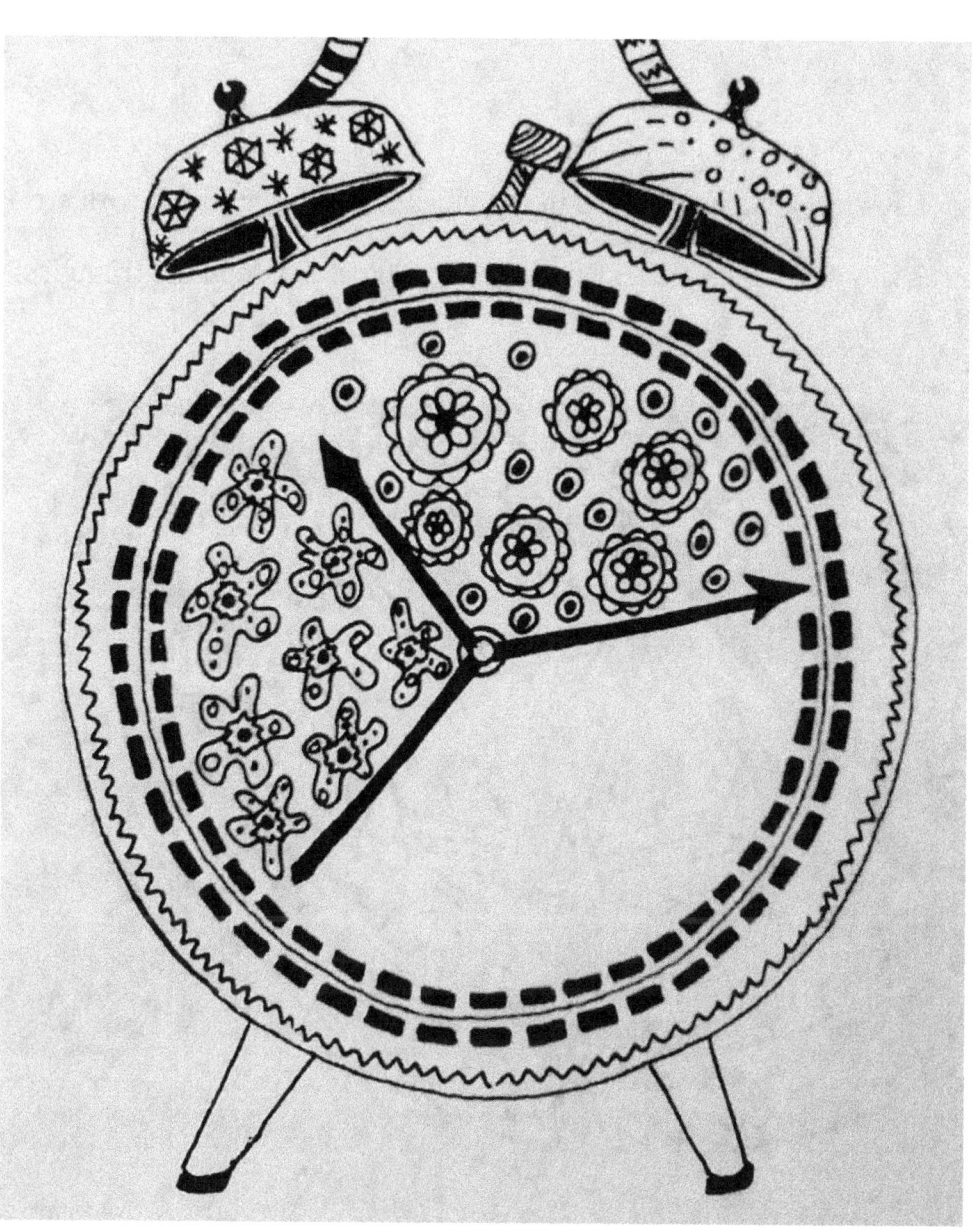

Step 6

Draw a few concentric triangles in the clock and connect them with straight lines as shown in the picture. Draw some *-shapes between the triangles.

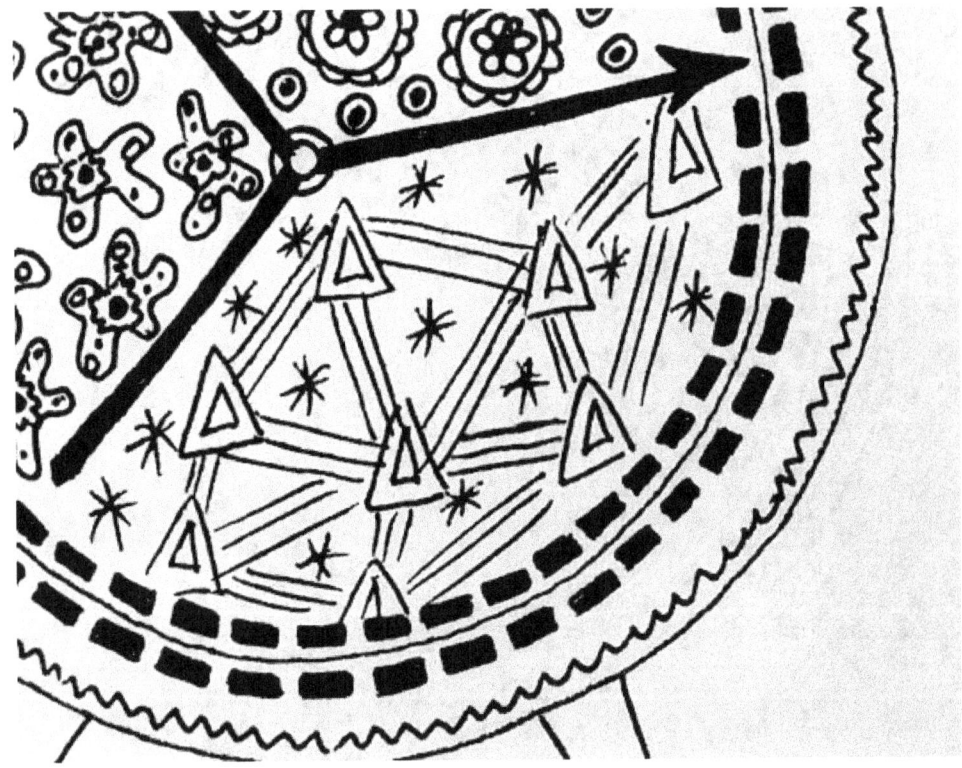

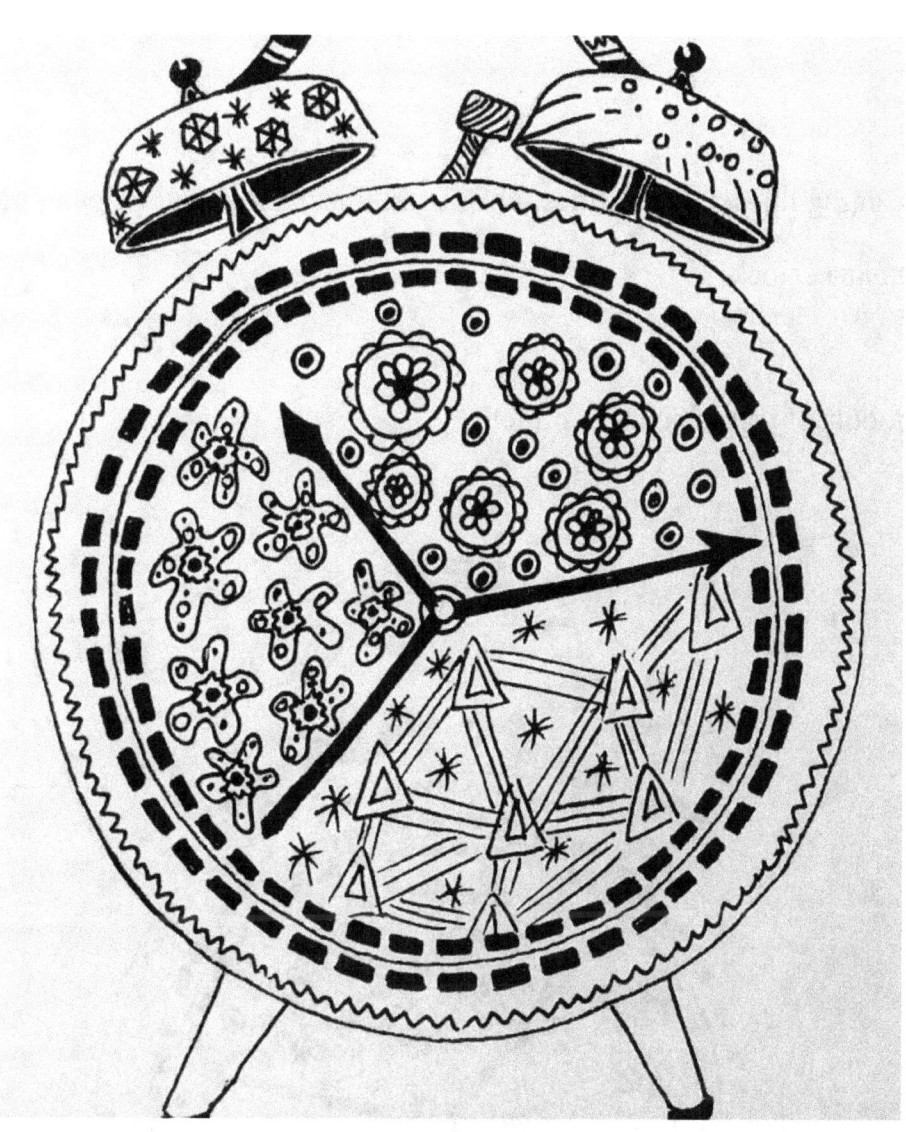

Step 7

Draw zigzag lines, vertical lines, horizontal lines, and small chips in the feet of the alarm clock.

The doodle of your clock is complete.

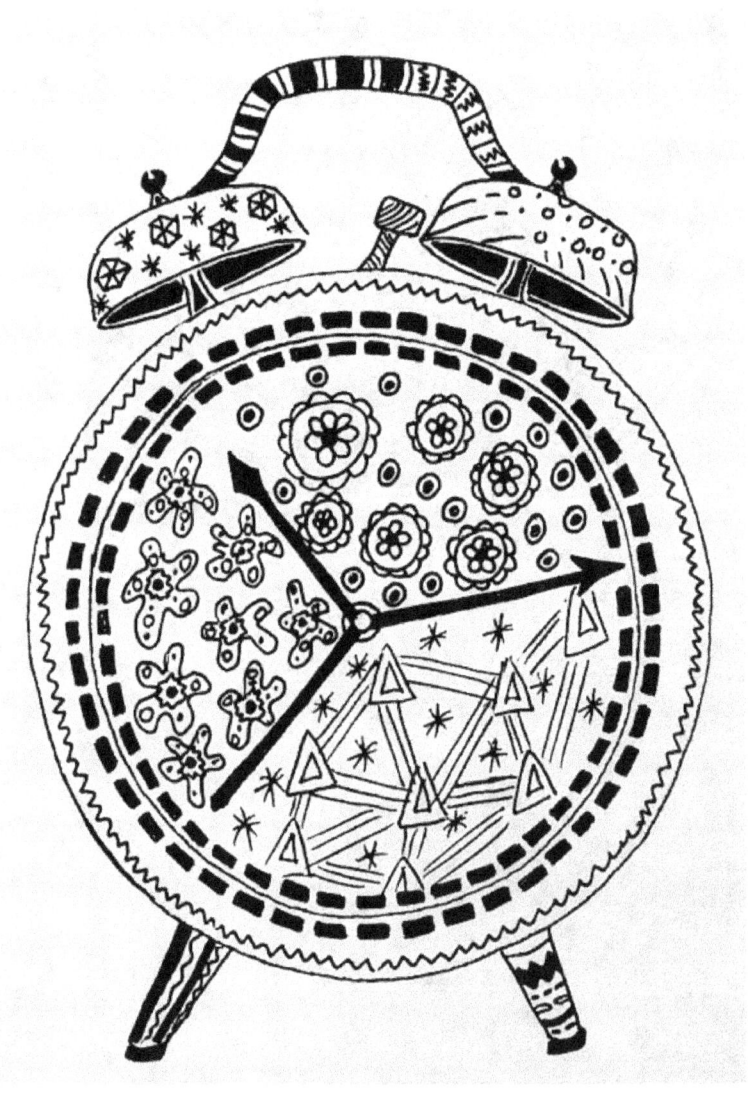

Chapter 1 Aladdin's lamp

The Middle Eastern Folk tale of Aladdin and his magic lamp is famous all over the world. You can never get bored of this tale and its majestic outlook. According to the story, Aladdin was a poor boy, who used to live in China and he lived with his mother. One day, they were fooled by a magician, who had come in the pretext of a rich merchant. He took Aladdin with him to Arabia. In reality, the merchant wanted Aladdin to take out the magical lamp from a cave from him.

When Aladdin was in the cave, he found the lamp and many other precious things, he asked the magician to pull him out. The magician refused to take him out and the poor boy just by luck rubbed the lamp. Thus, genie emerged from the lamp and became Aladdin's servant. The ups-and-downs of Aladdin's life along with his wife make the story very interesting to the kids and adults alike. Let us now explore how we can doodle Aladdin's lamp:

Step 1

Draw the basic pencil outline of Aladdin's lamp with beautiful curves.

Step 2

Finalize the outline of the lamp using an ink pen. Draw some curved lines in the cap of lamp.

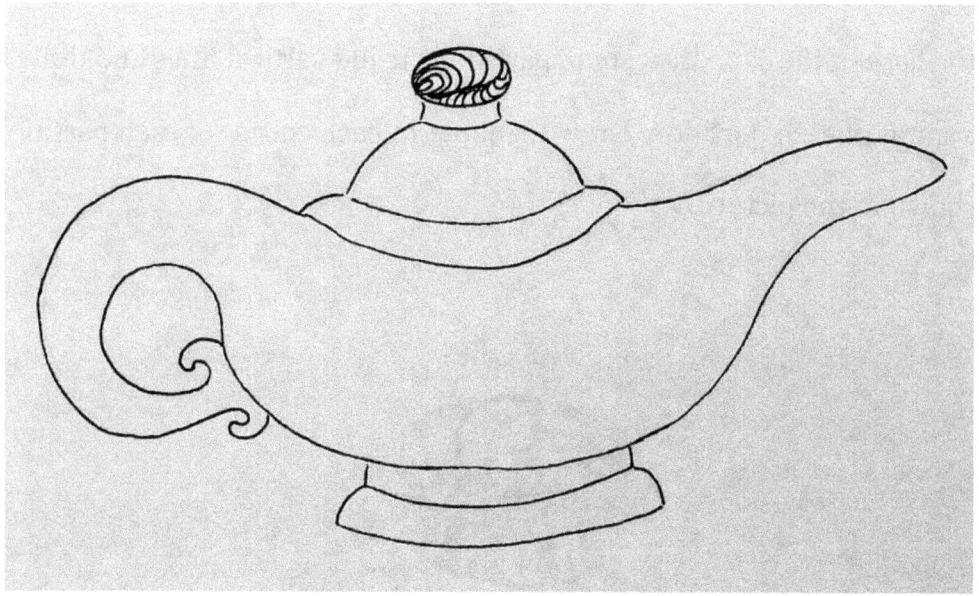

Step 3

In the lower portion of the cap, draw some concentric triangles and connect them with straight lines.

In the base of the cap, draw some partitions using vertical lines and draw one spiral in each partition. Draw L-shapes in each corner of each partition as shown in the picture.

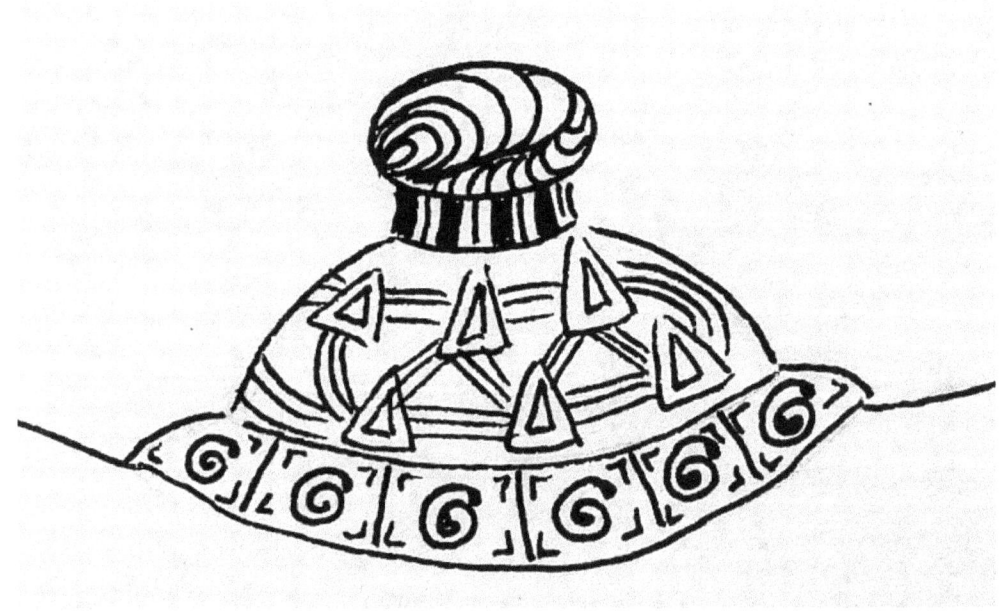

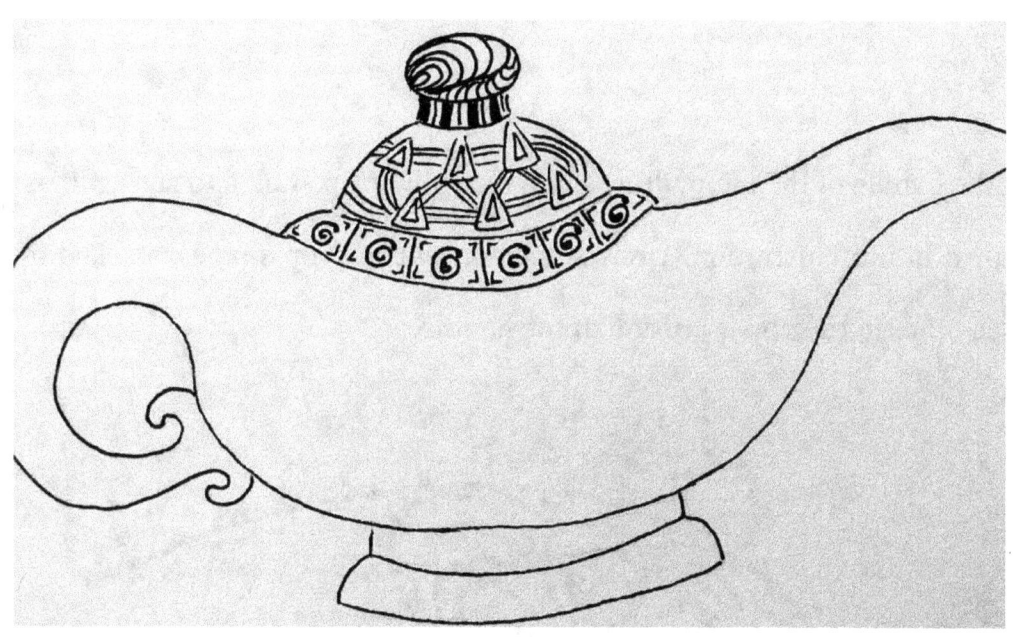

Step 4

In the handle of the lamp, draw some vertical, horizontal, and zigzag lines as shown in the illustration. Draw some concentric drop shapes, stacked over each other in the upper portion of the handle.

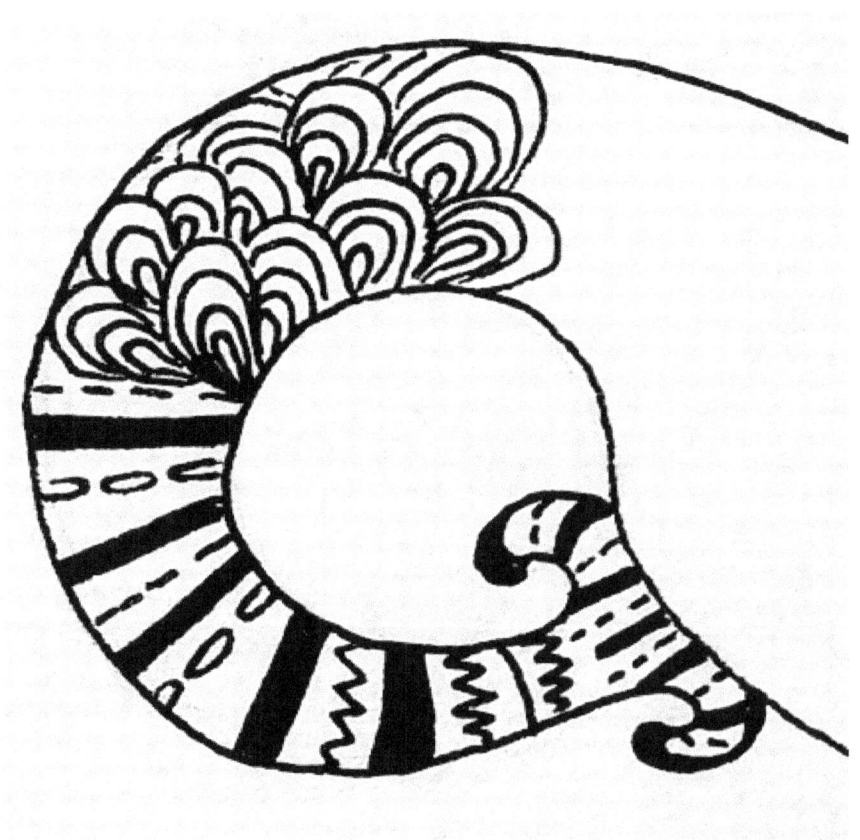

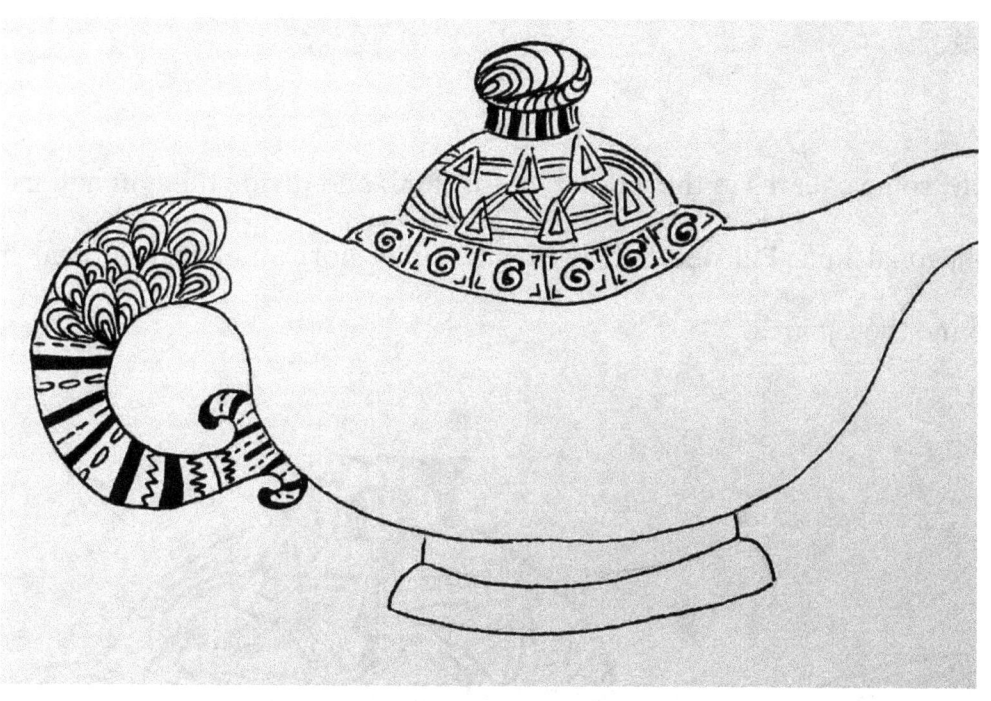

Step 5

Draw some squares in the left half of the lamp and divide them in half using a diagonal line. Fill one-half with ink. Draw horizontal and vertical line around the squares.

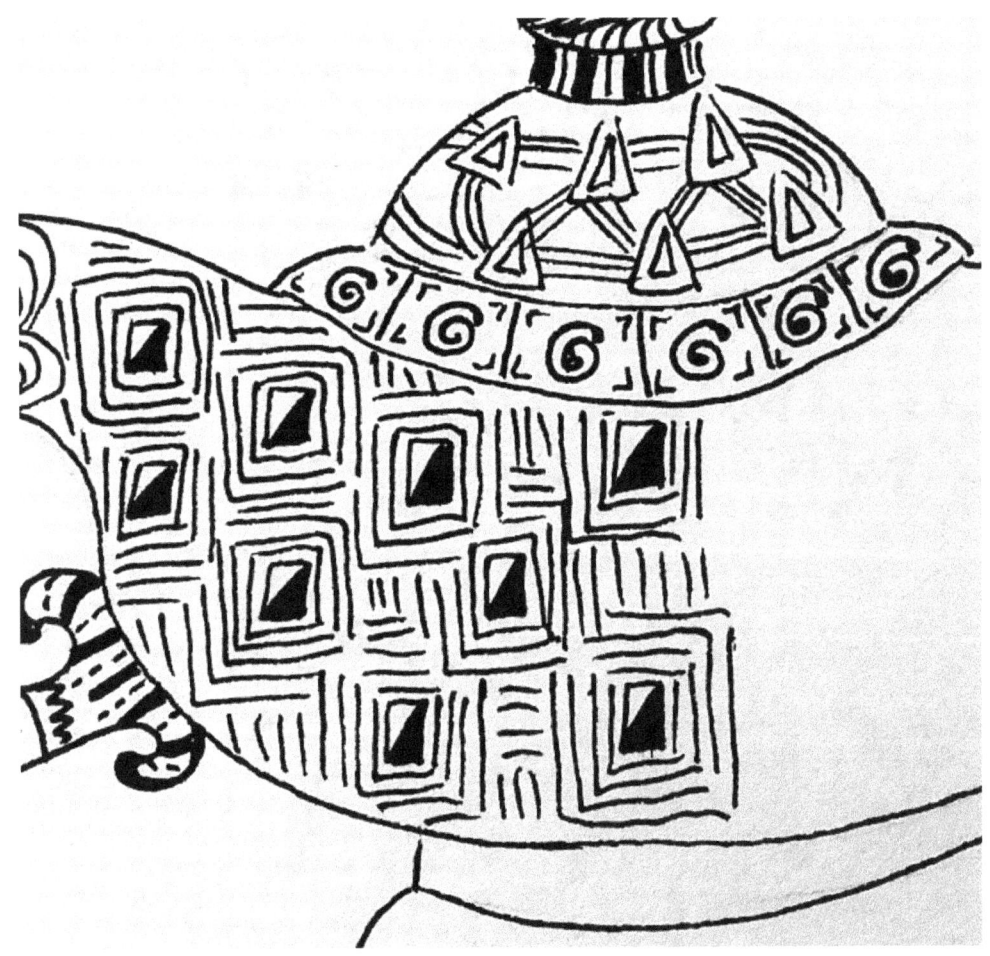

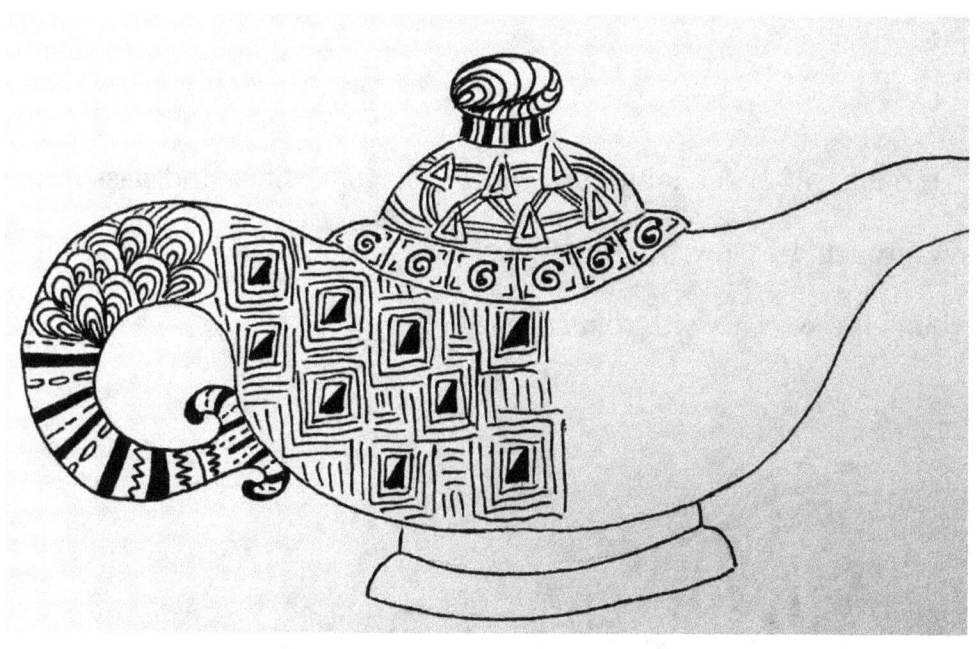

Step 6

In the right half of the lamp, draw a few diagonal lines and pass a line of wave through it. Now, fill the wave with ink as shown in the picture. Surround these waves with some dashed lines.

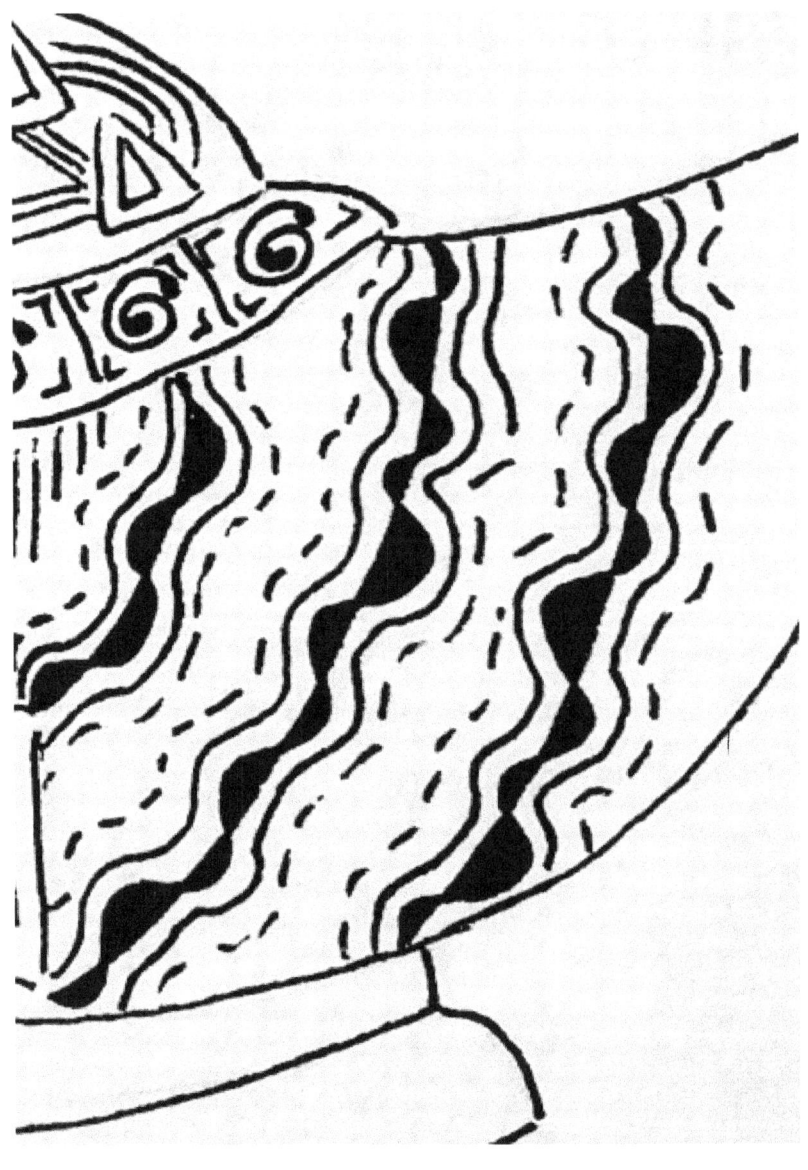

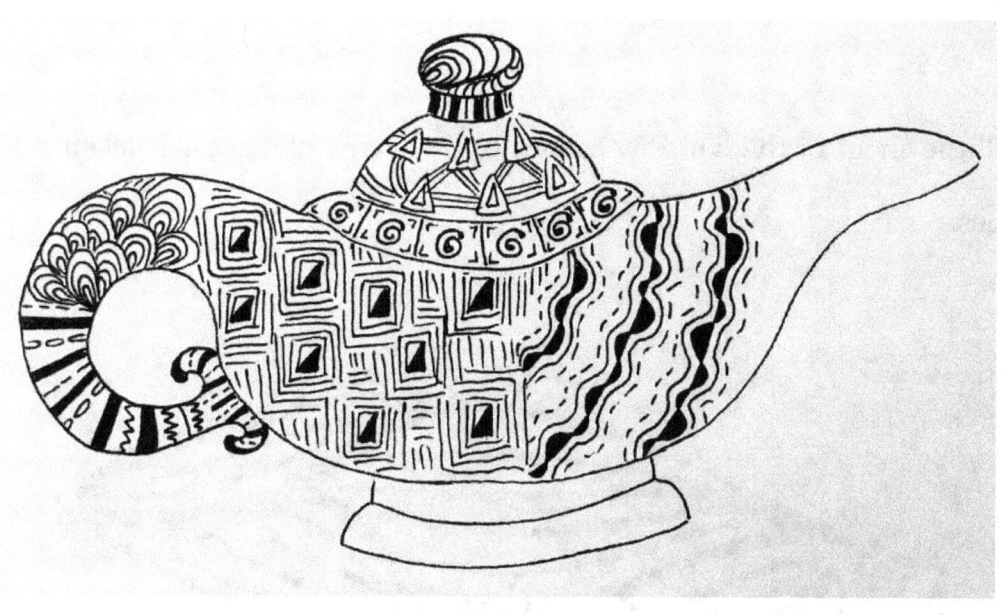

Step 7

Fill the snout of the lamp with lines in the shape of leaves. Thicken a few lines.

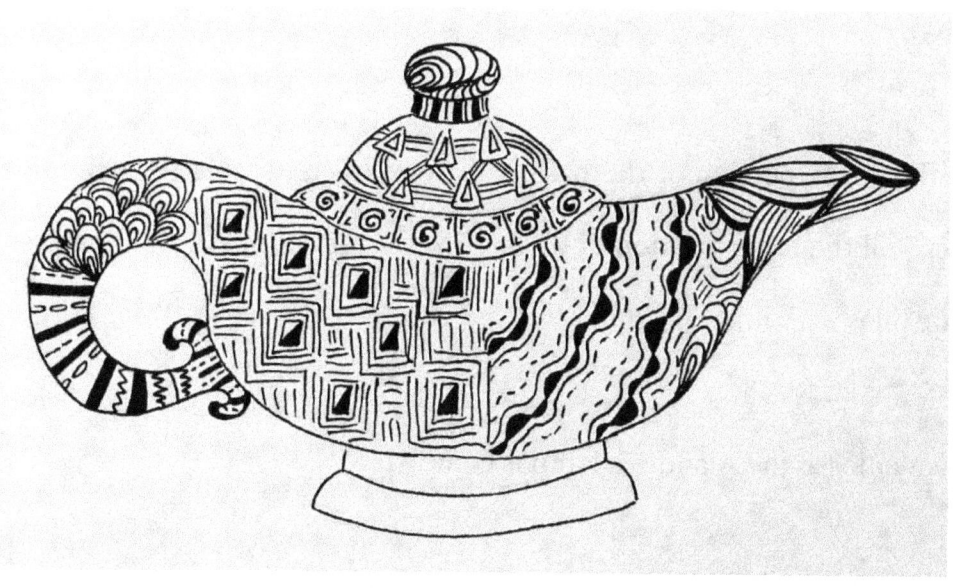

Step 8

Fill the upper portion of the base with semi circles facing opposite to each other. Fill the lower portion of the base with zigzag lines and fill one section of the lines with ink.

The doodle for the Aladdin's lamp is complete.

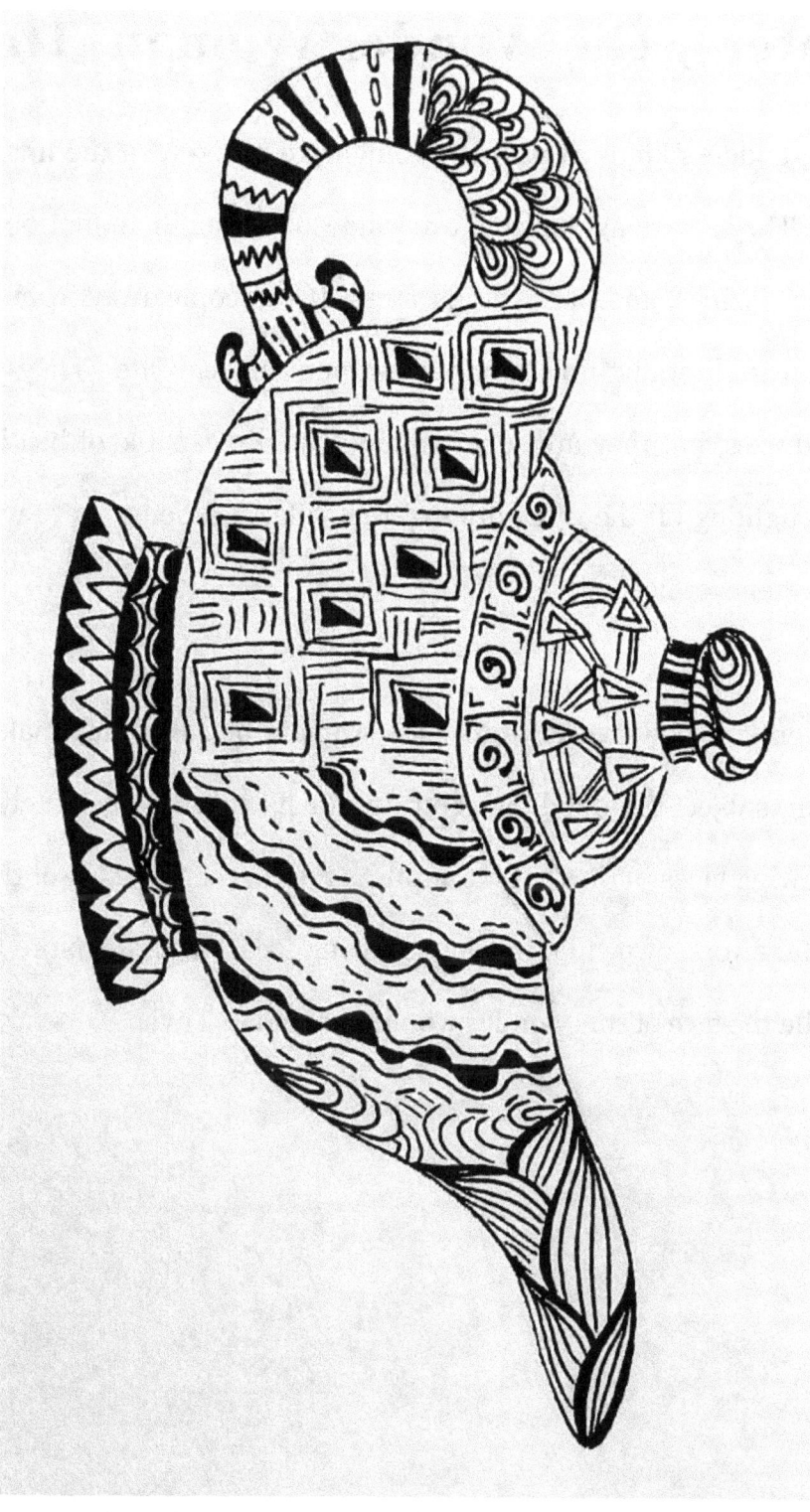

Chapter 3 The Wonder Woman- Thyia

The demi-goddess kinds of wonder women are not new in the imagination of artists. They are being depicted every now and then in animation movies, cartoon magazines, and in clothing ranges. If you come away from fictional life, you can literally find wonder women in real life. They are not demigoddesses, but they are superwomen who are capable of beating their enemies, fighting off the difficulties of their life, and being there with their families whenever needed.

It is not only a challenge to draw such women, but also they make a very interesting subject for doodling. You do not have to be absolutely perfect while drawing faces in the first attempt. As told in the first part of this book, you can take your own time to learn drawing faces. Let us explore how you can doodle the face of this wonder woman named as Thyia.

Step 1

Draw the outline of side profile of Thyia using pencil. Adjust mistakes, if any, while you are drawing with pencil. Since we are drawing a human face here, it will be difficult to adjust mistakes later.

43

Step 2

Draw the facial features of Thyia with pen. Draw the eyes with precision; only one eye is completely visible. The other eye is barely visible from the side profile; only the eyelashes can be seen behind the nose. Below the eyebrow, draw some circles and then a trail of dots. Fill the upper lip with full ink and the lower ink with vertical lines.

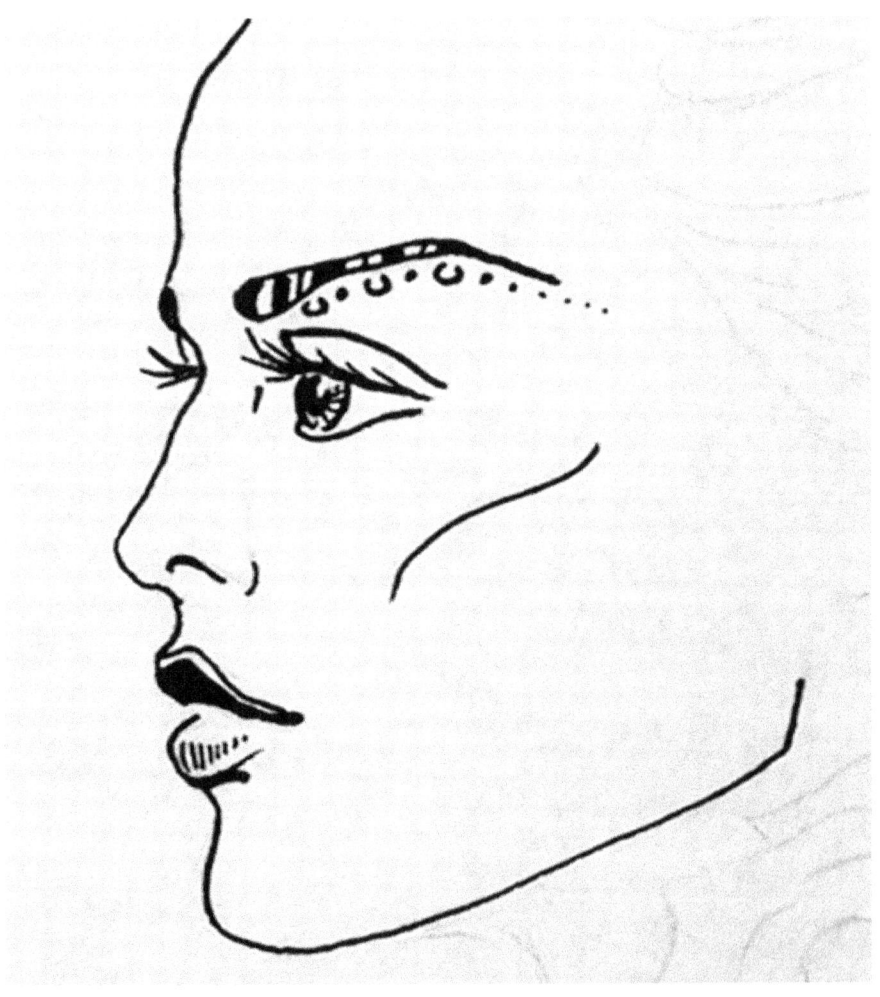

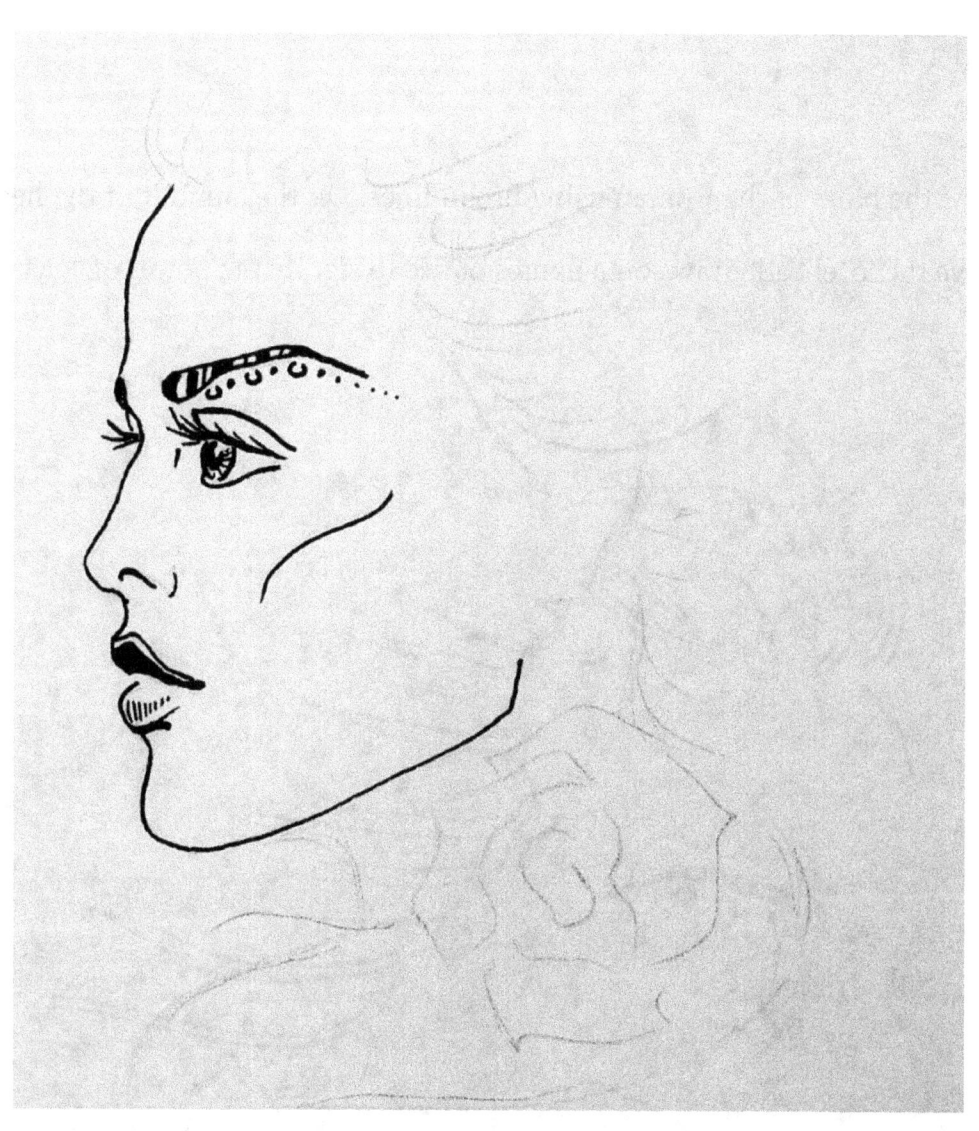

Step 3

Draw the hairs of the woman using broad lines. On the summit of the head, above the forehead, draw some flames of fire to signify the power of Thyia.

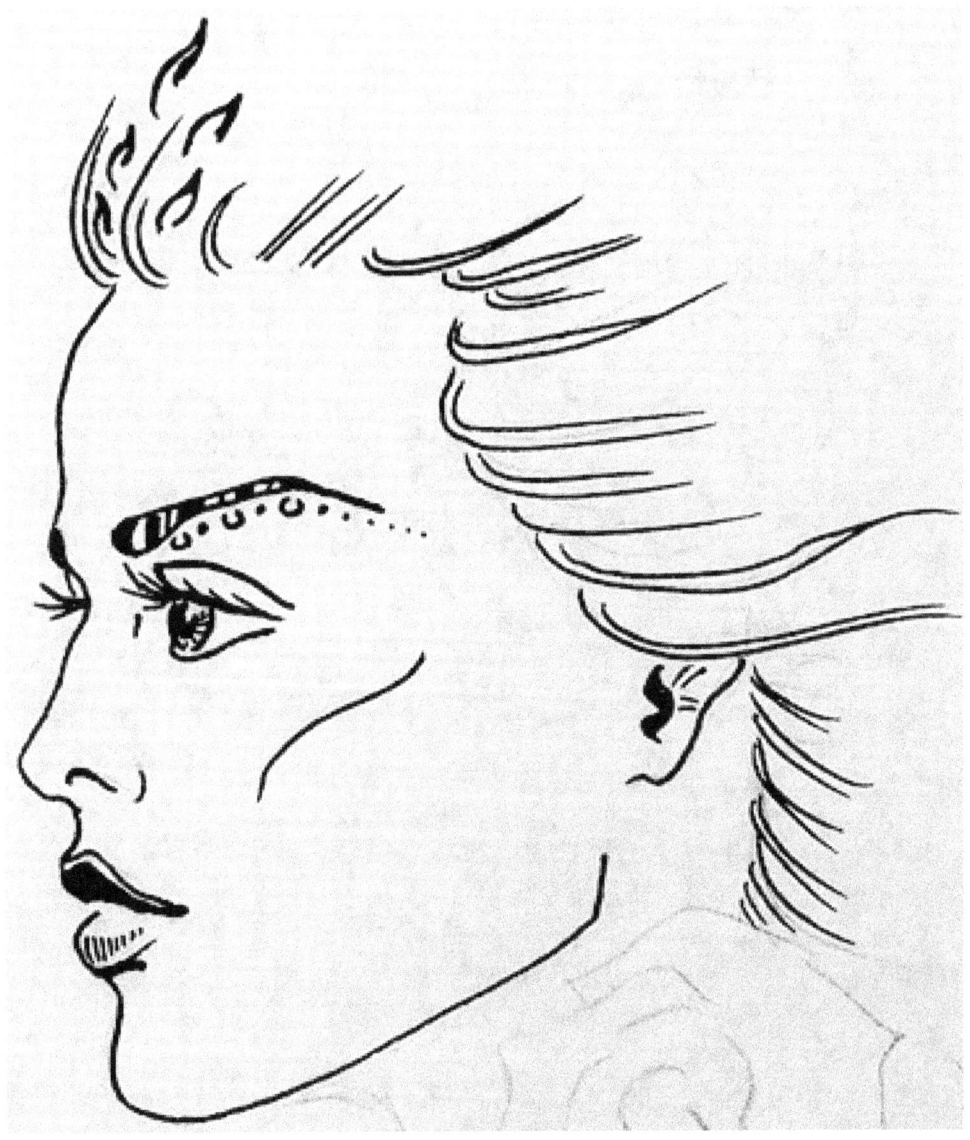

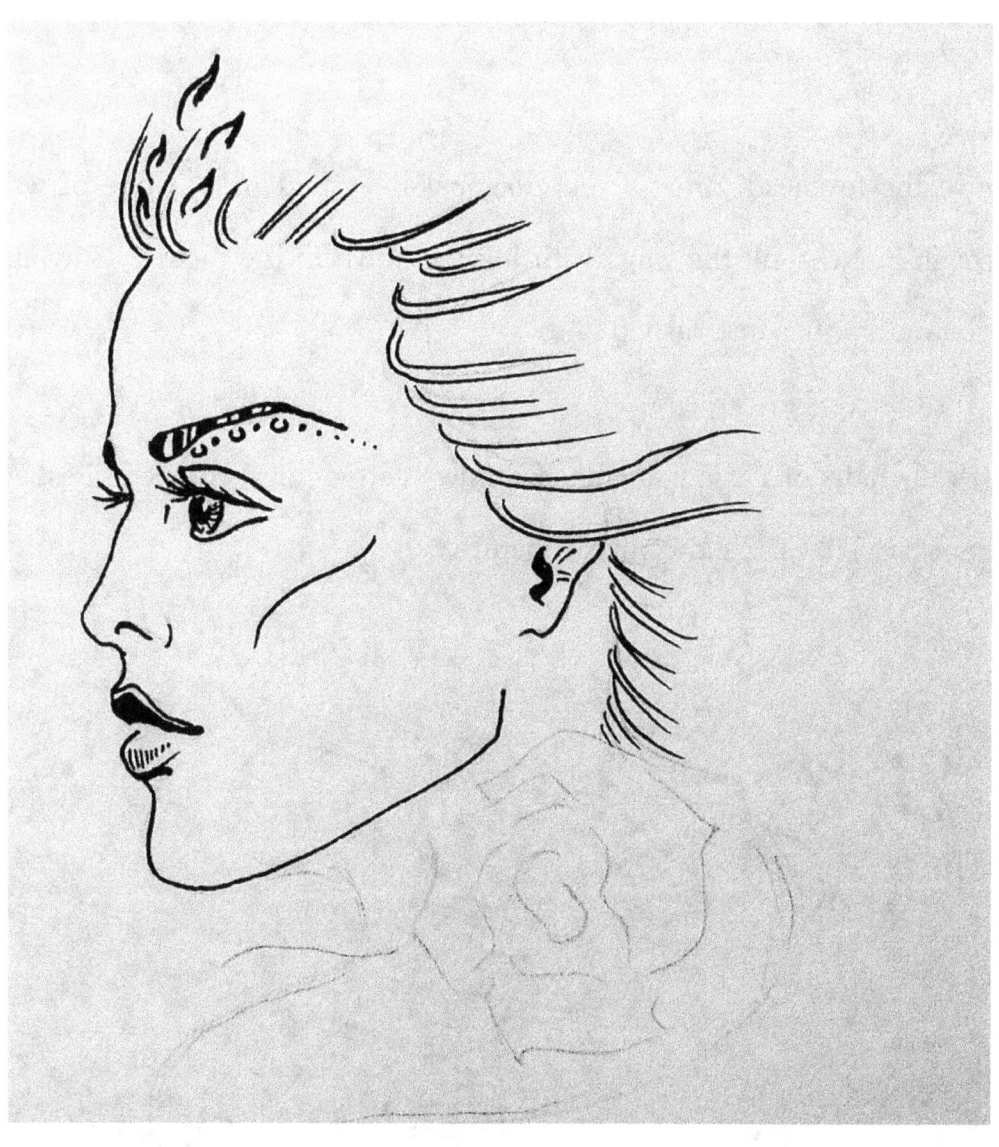

Step 4

Above the forehead, draw a few diagonal lines and pass a line of wave through it. Now, fill the wave with ink as shown in the picture. Surround these waves with some dashed lines.

Draw the hairs of Thyia using dashed lines, dotted lines, chipped lines, and other curved lines as shown in the picture.

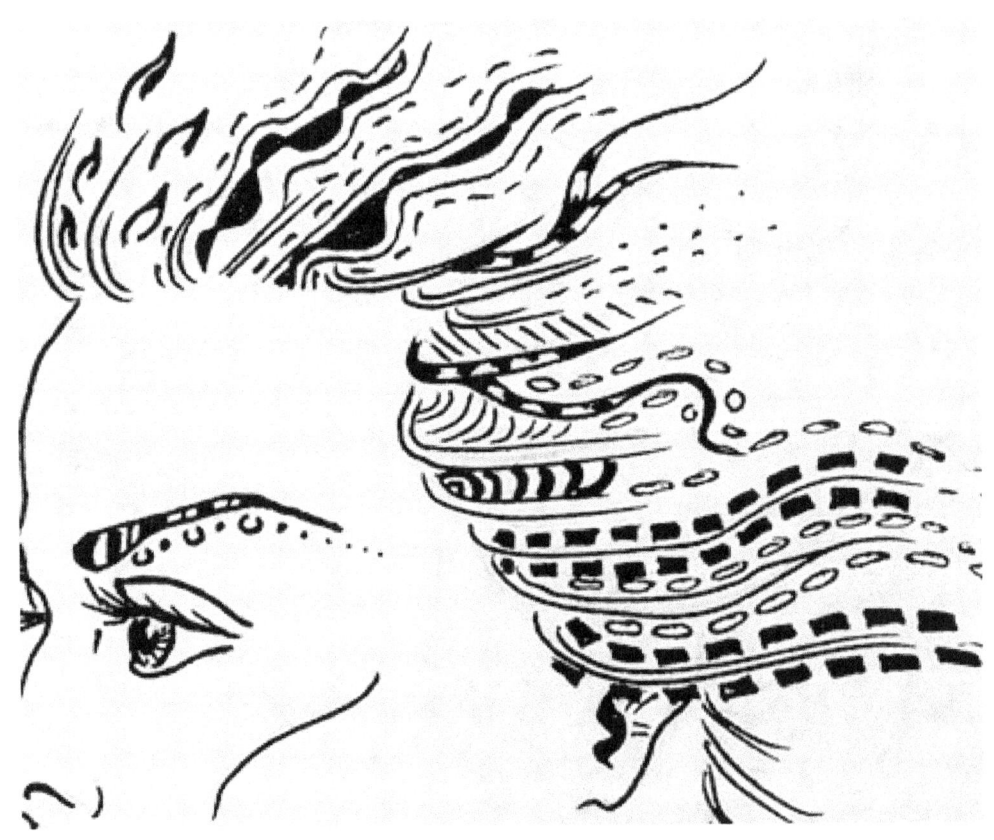

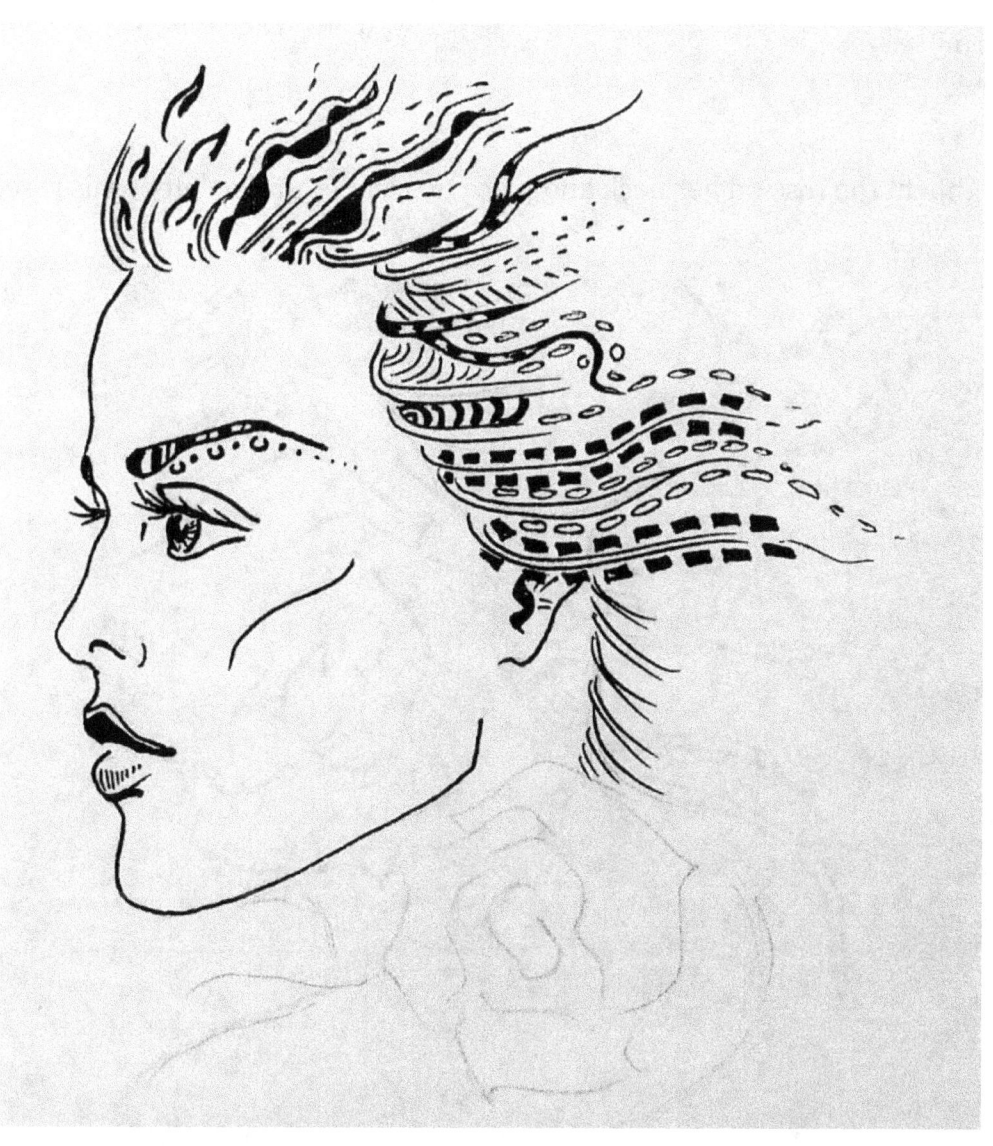

Step 5

Highlight the rose on her neck and place two circles on the left of this rose.

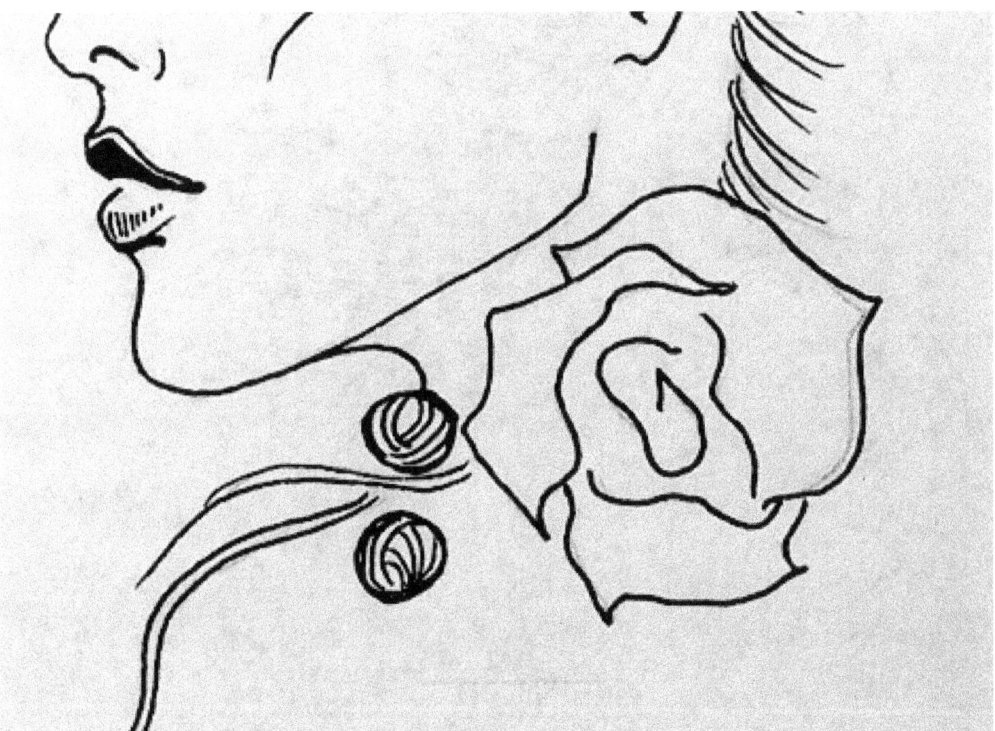

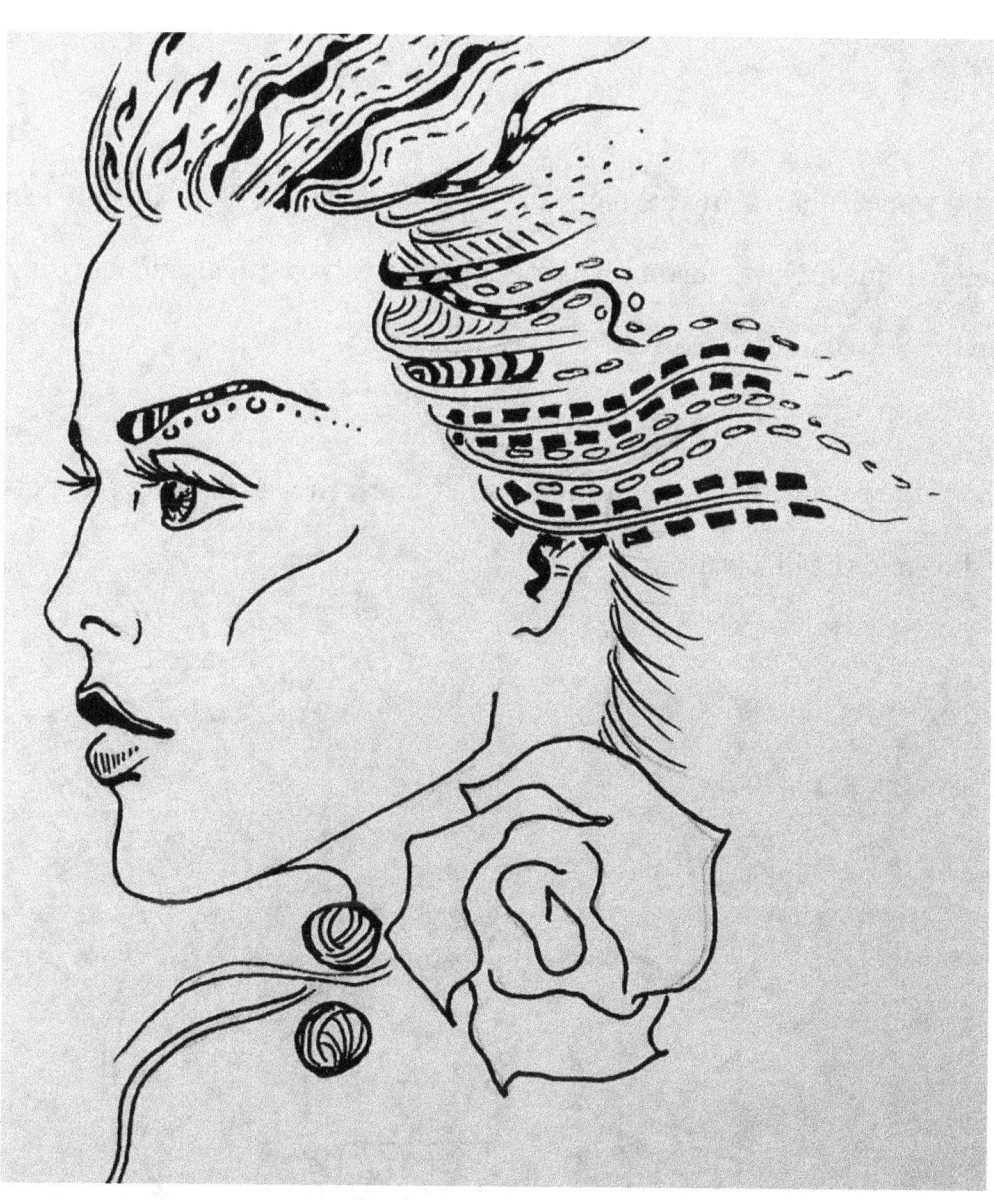

Step 6

Draw some squares in the hairs of Thyia and divide them in half using diagonal lines. Now, surround these squares with vertical and horizontal lines as shown in the picture.

Fill up the rose with chipped lines, dashed lines, circles, flowers, and petals as shown in the illustration.

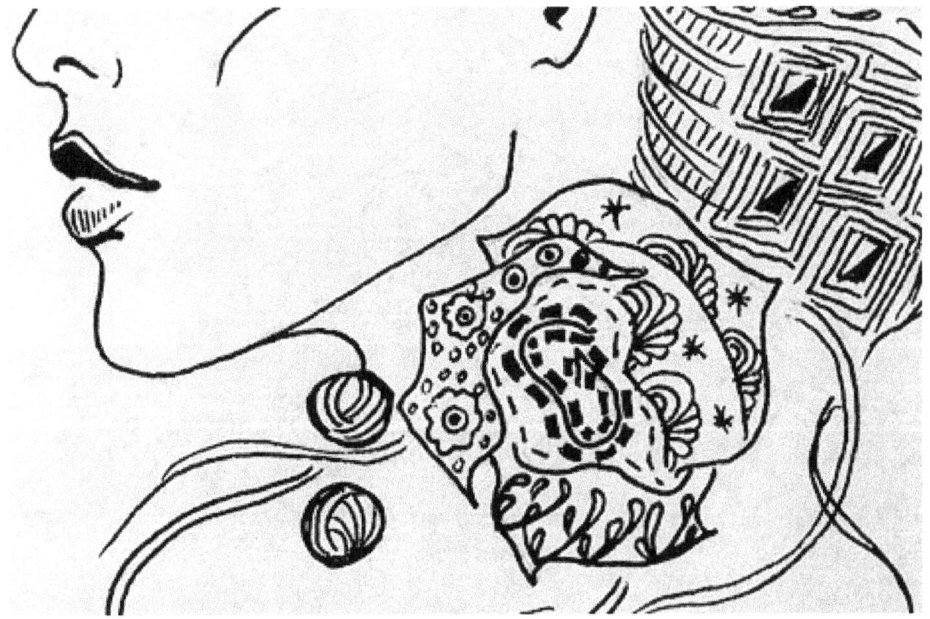

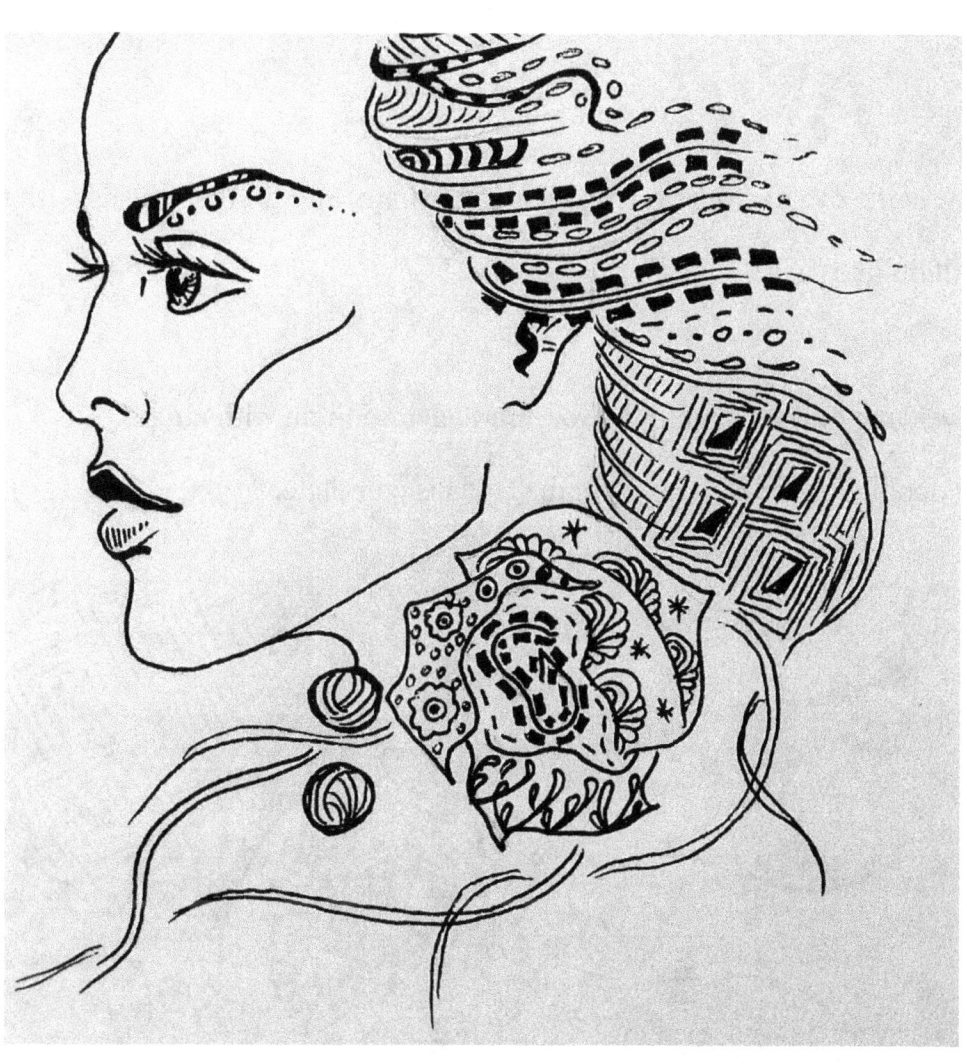

Step 7

Draw some ovals in the flowing area of her hairs and fill these ovals with two small bullets each.

Draw some bullets around the rose and enclose them with circles.

The doodle for the wonder woman, Thyia is complete.

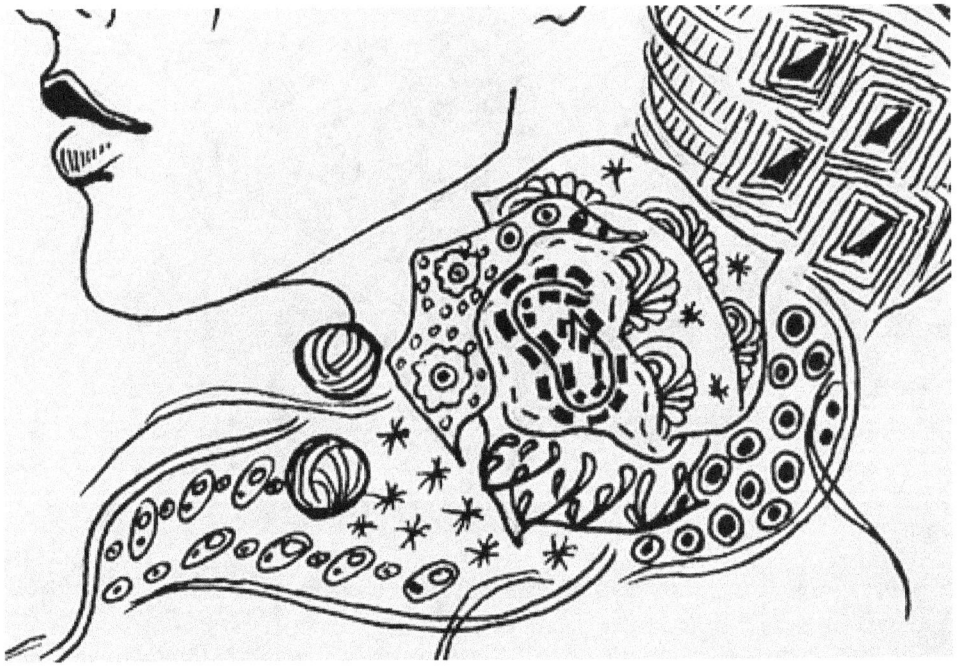

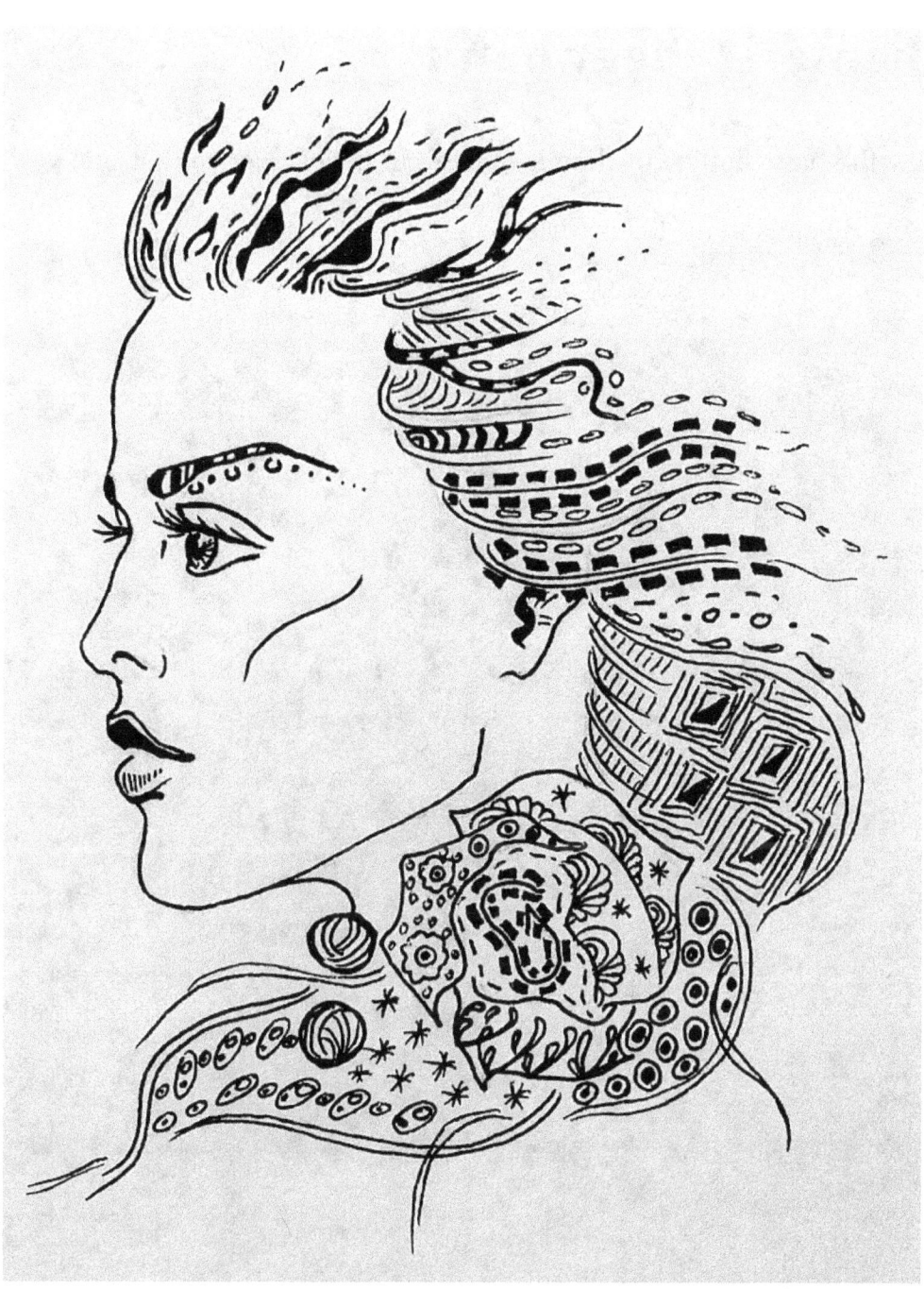

Chapter 4 Piggy bank

Draw the basic outline of the piggy bank in pencil. Notice that one year of the pig is bent and the tail is curled.

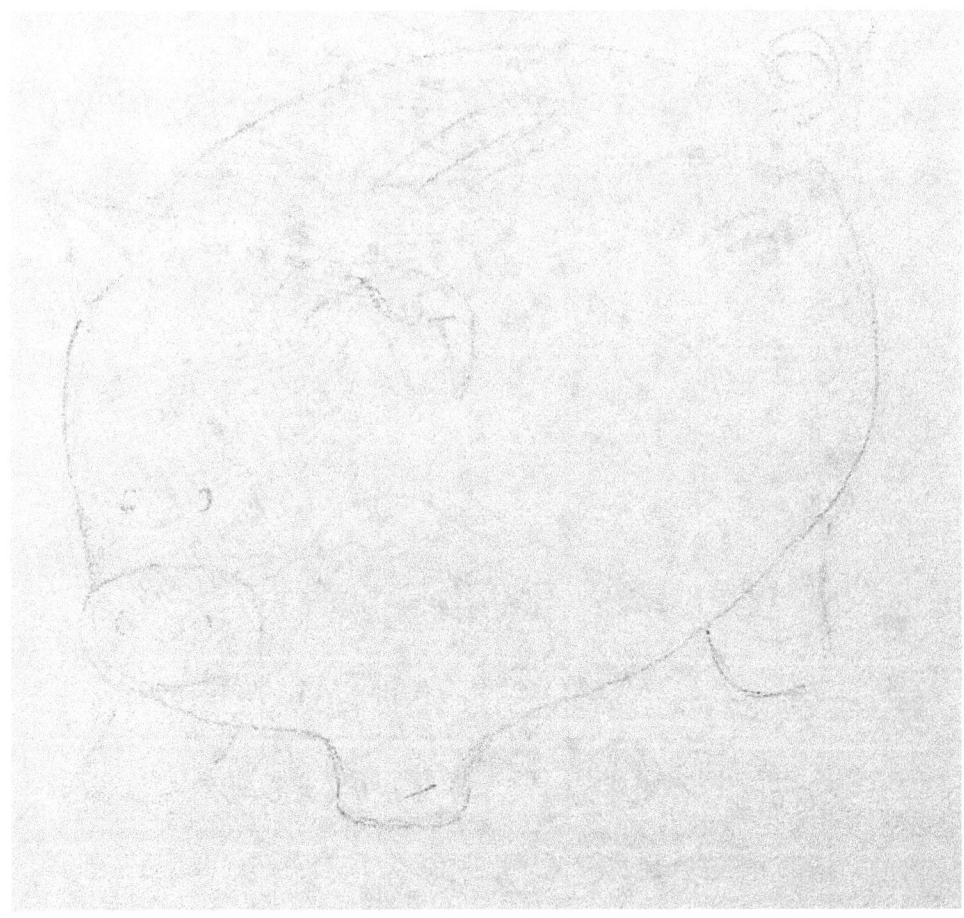

Step 2

Highlight the outline with pen. Draw the eyes and nostrils of the piggy bank.

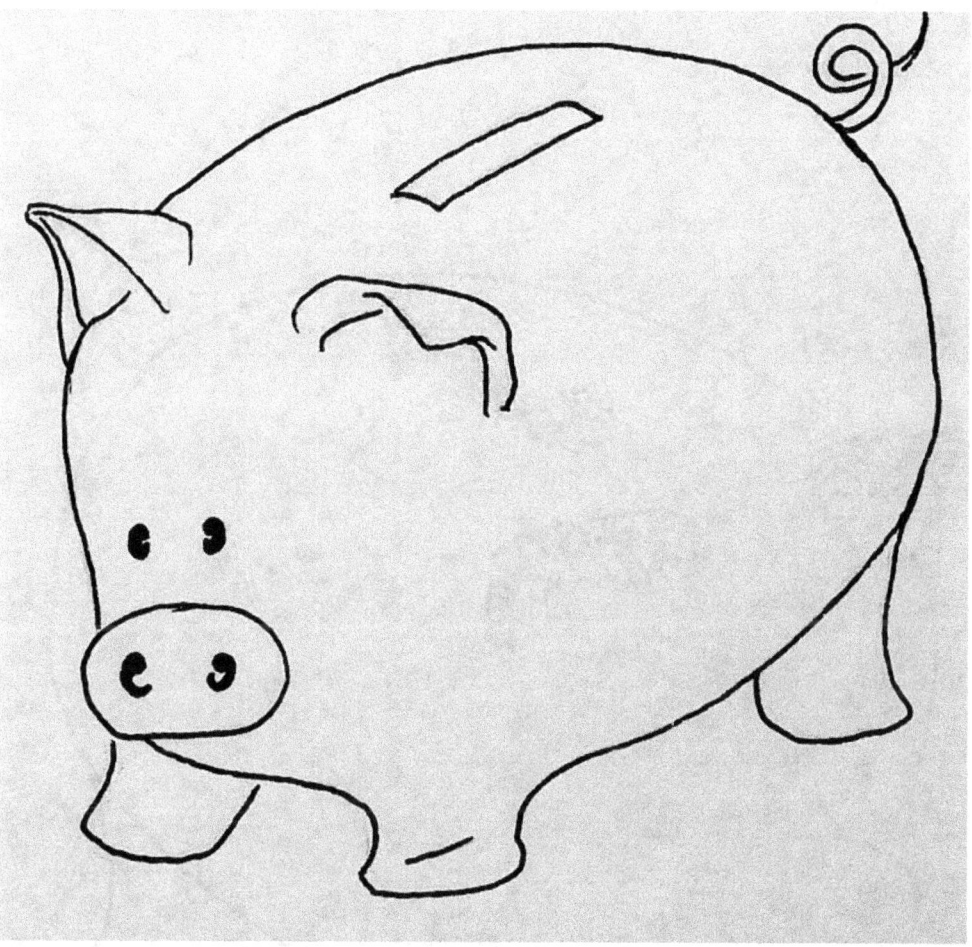

Step 3

In the left year of the pig, draw some curved lines, dots, and horizontal lines. In the right ear of the pig, draw some floral petals, some semi-circles, and a few vertical lines.

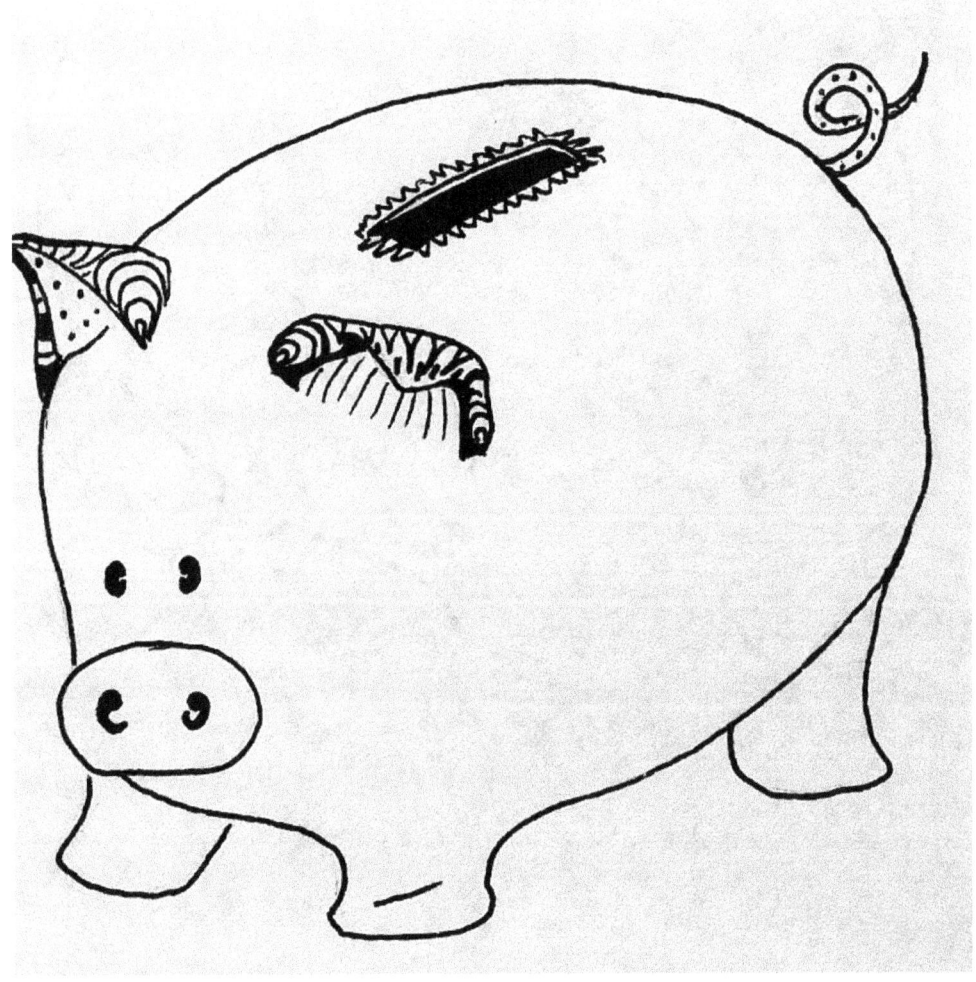

Step 4

In the nose of the pig, draw a few checks and add one bullet in each square. In the face, near the nose, draw some hexagons and surround them with *-signs. Keep the designs loosely placed with each other.

Fill the coin slot with ink and surround its edges with zigzag lines. In the left foot of the pig, draw diagonal thick lines and insert zigzag lines in between.

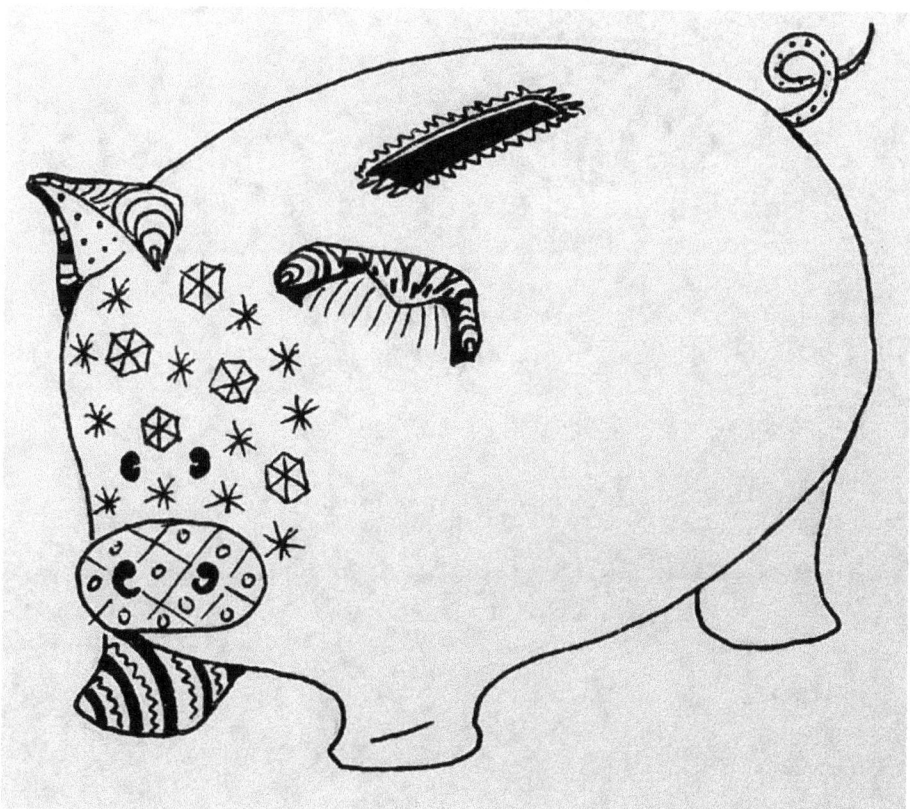

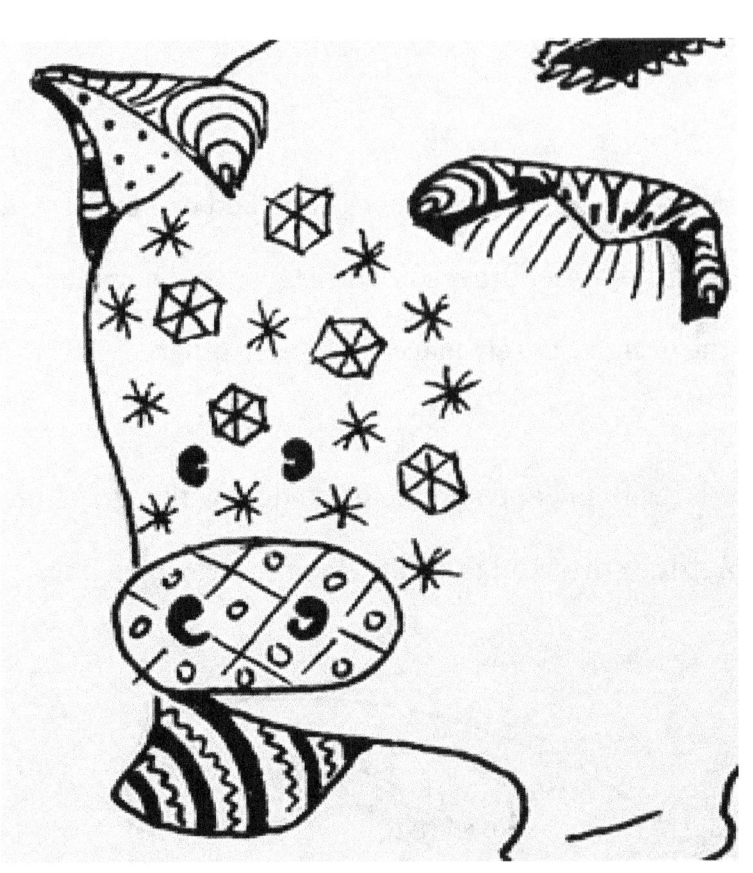

Step 5

In the lower portion of the face, near the nose, draw large checks and draw one swirl in each square. Draw L-shapes in each corner of each square. Highlight both the tips of each swirl with slightly thick bullets. Extend this design to the right foot as well. When there is no space to insert a swirl, you can simply insert a line.

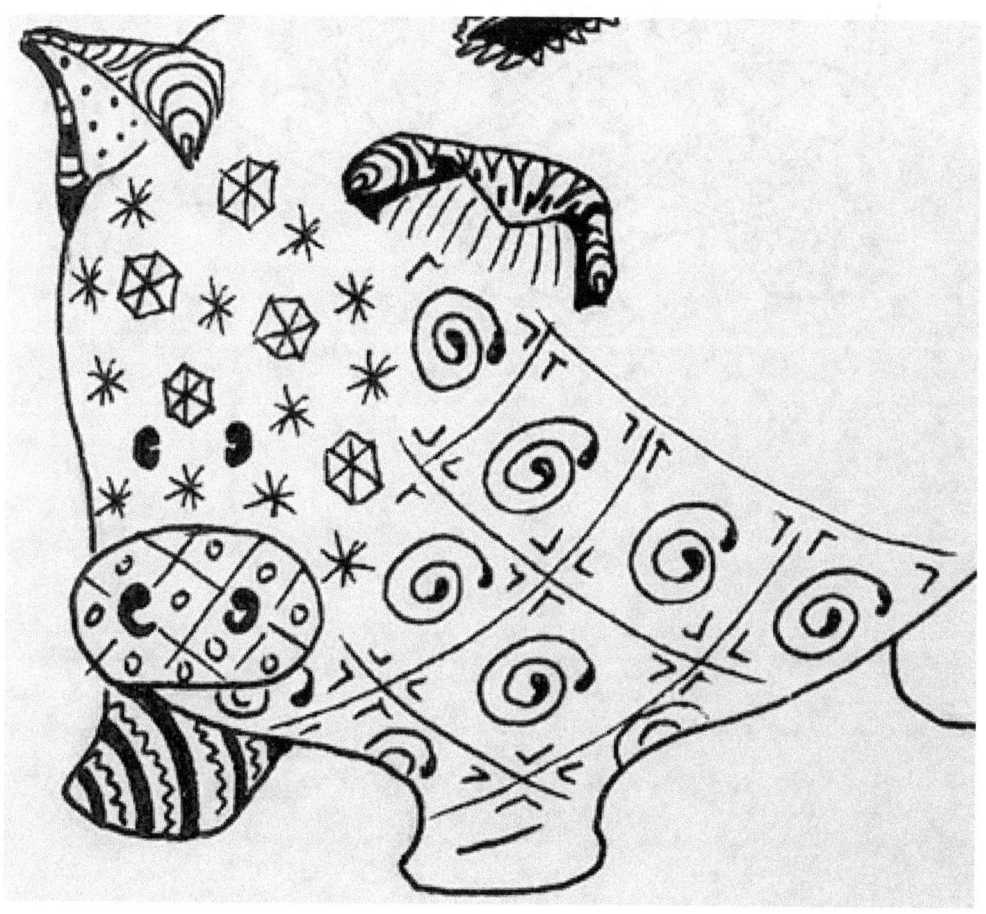

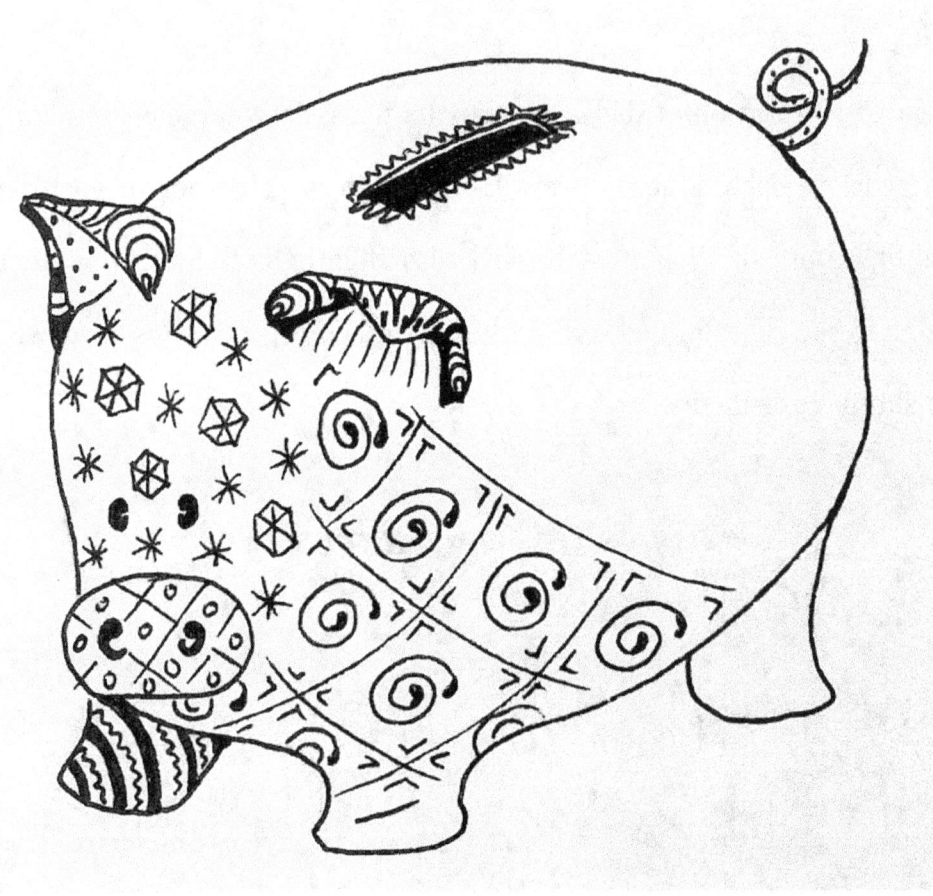

Step 6

In the back area of the body, draw a wave, and surround it's both sides with chipped lines.

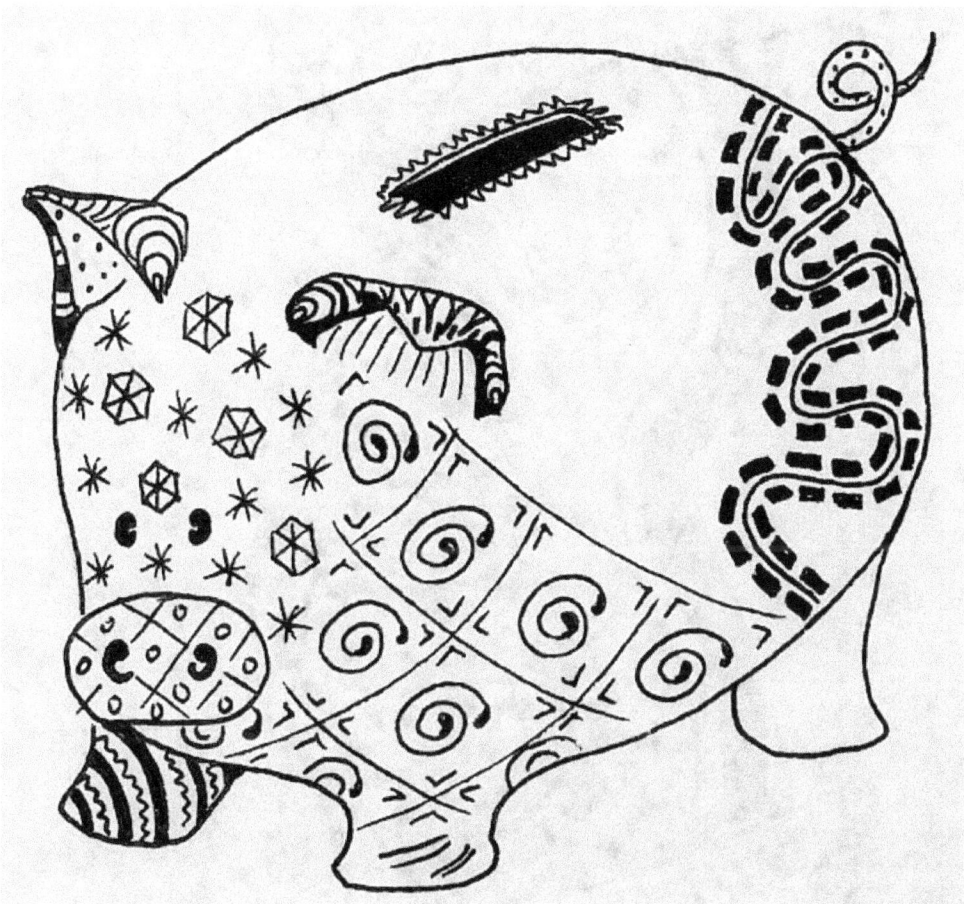

Step 7

Separate the section of chipped lines with a thick wave as shown in the picture.

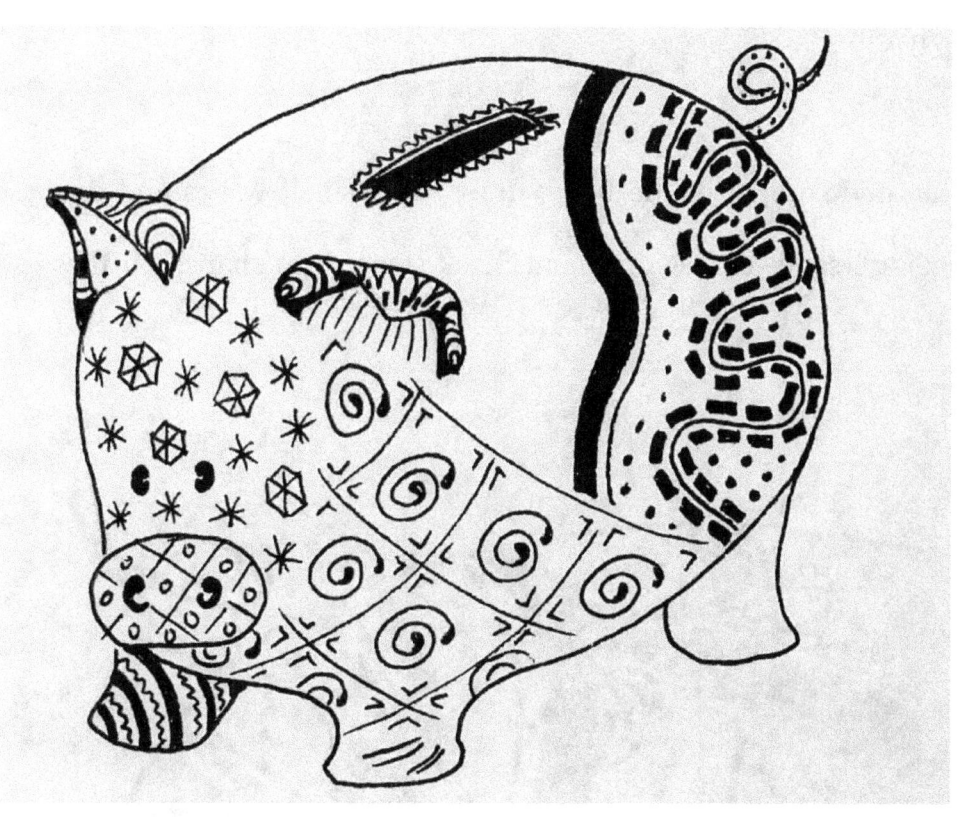

Step 8

In the middle area of the body, draw some small waves and draw some concentric semi- circles on them. Stack some drop shapes on these semi- circles.

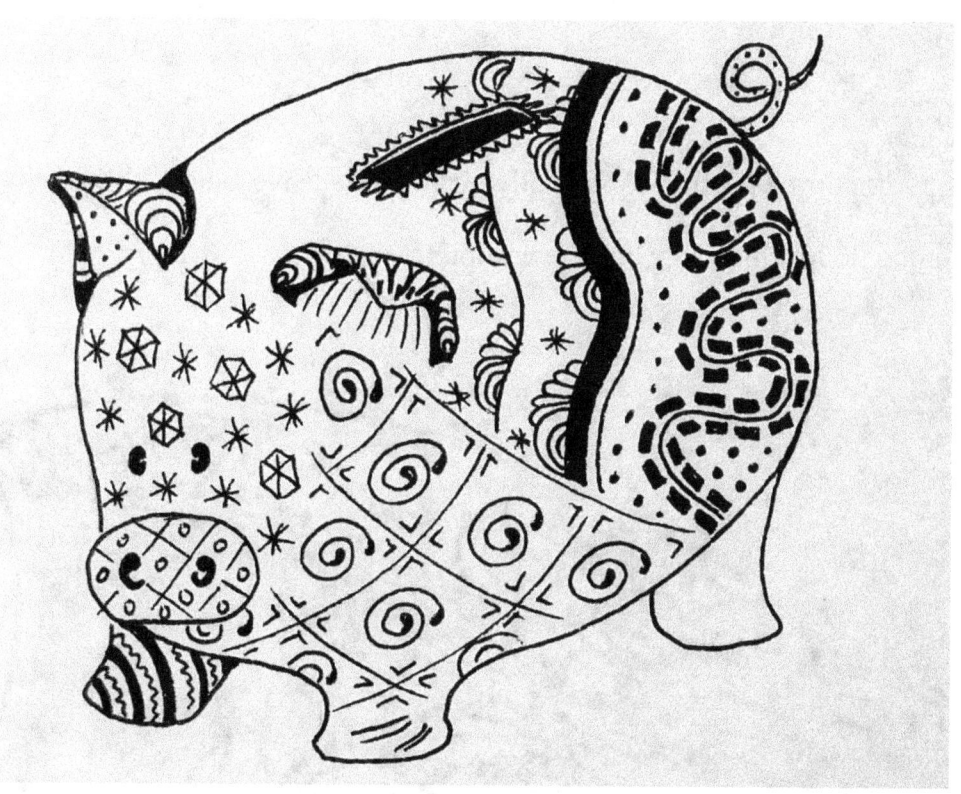

Step 9

In the remaining portion of the body, draw some leaves and *-shapes.

The doodle for this piggy bank is complete.

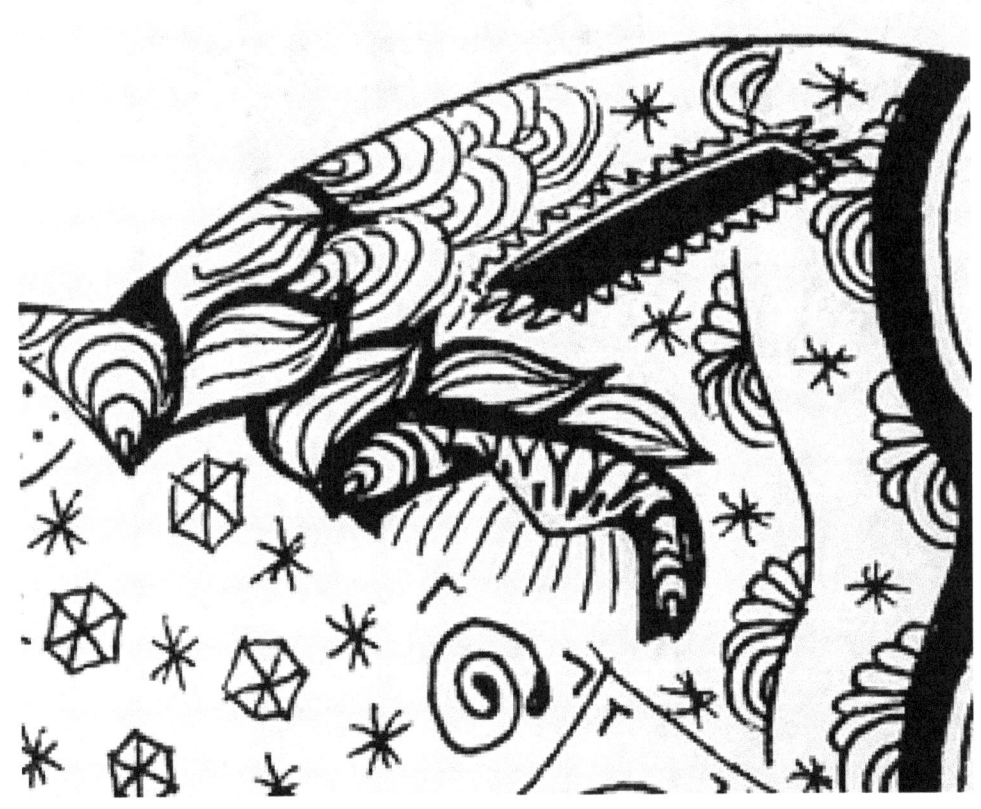

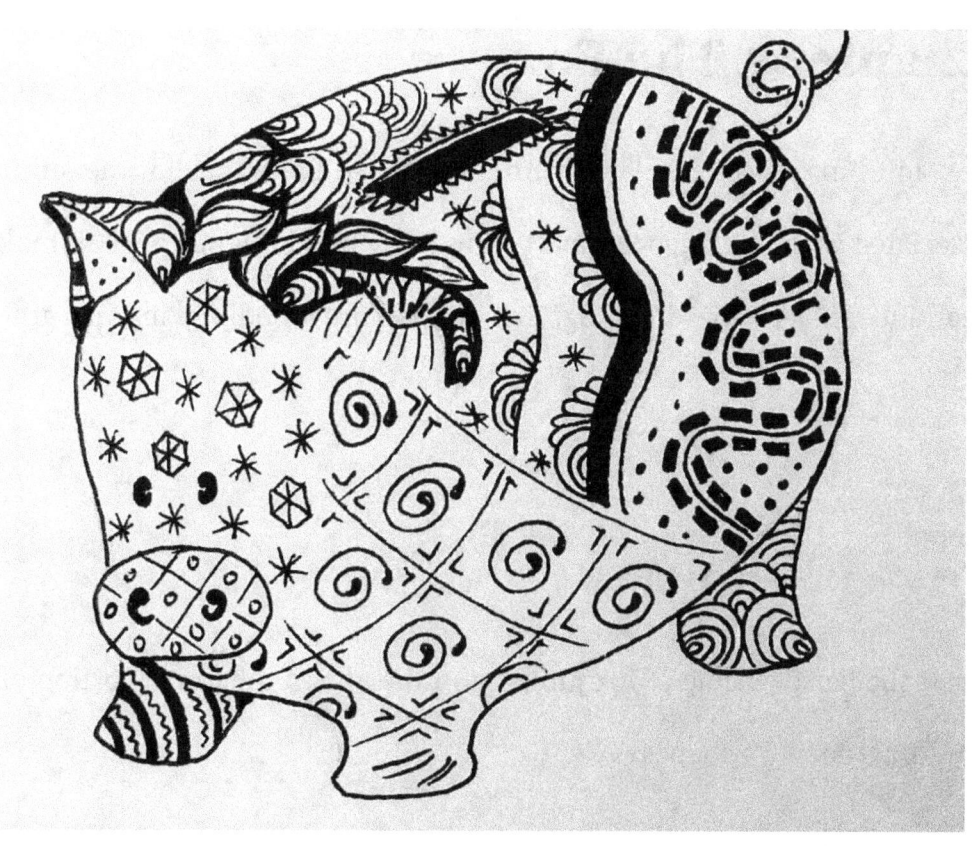

Chapter 5 The Fox

Fox, in China, is often related with afterlife. In Celtic Realm, the animal is associated with intelligence. Apart from its symbolic significance, it makes a beautiful subject for doodling. Let us explore doodling in this graceful animal.

Step 1

Draw the basic outline of fox jumping in the air. In the lower portion of her jaw, draw a few V- shapes.

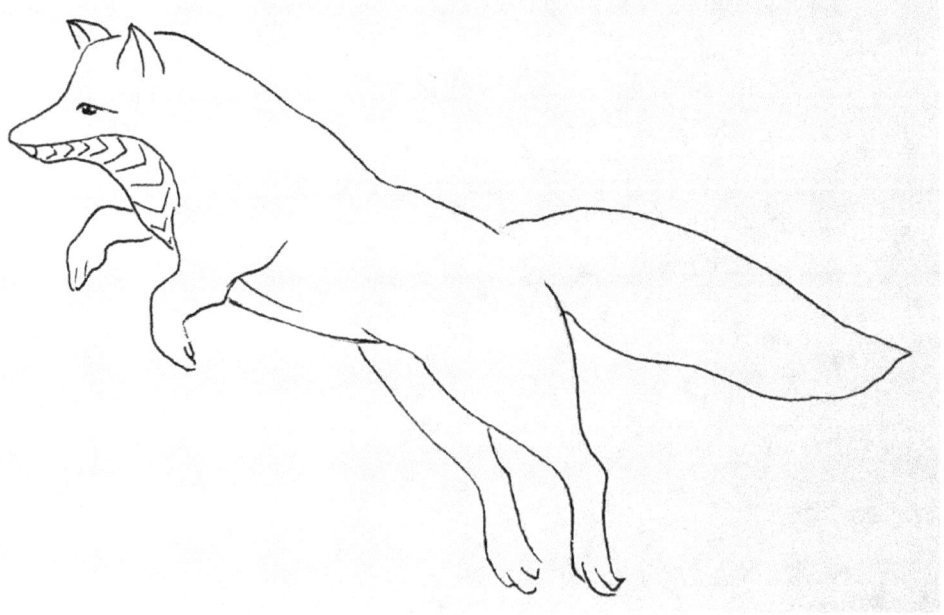

Step 2

Carve out a small section in the upper portion of her jaw, and draw a few parallel arcs. Draw a few *- shapes around the eye and separate this section with a small wave. Fill up the ears with small dots and parallel thick lines. Fill the front side of the ears with ink.

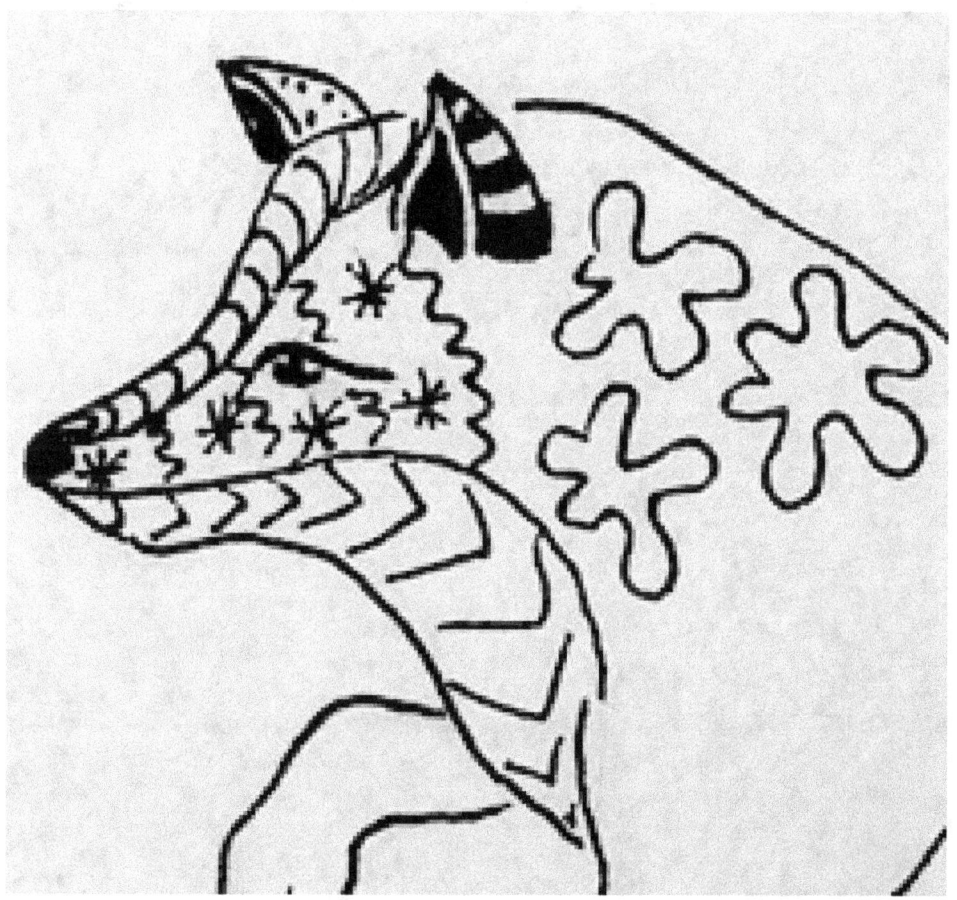

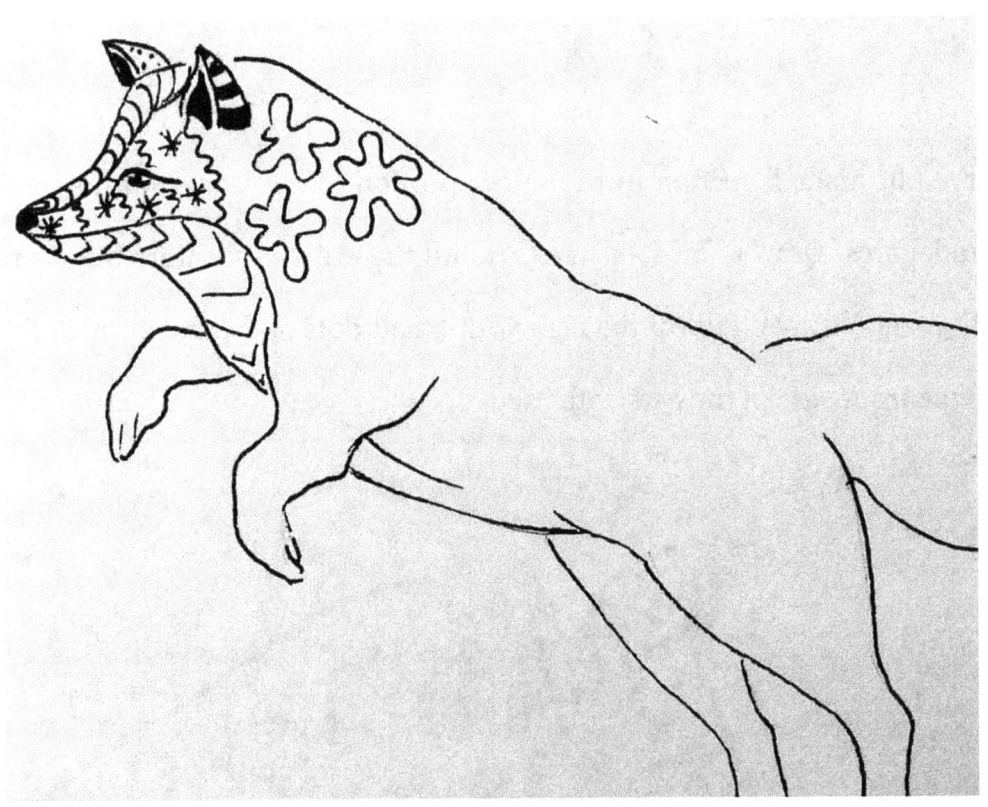

Step 3

Draw a few amoeba shapes after the ear and fill them with designs as shown in the picture. Draw a branch of flowers emerging from her feet as shown in the illustration.

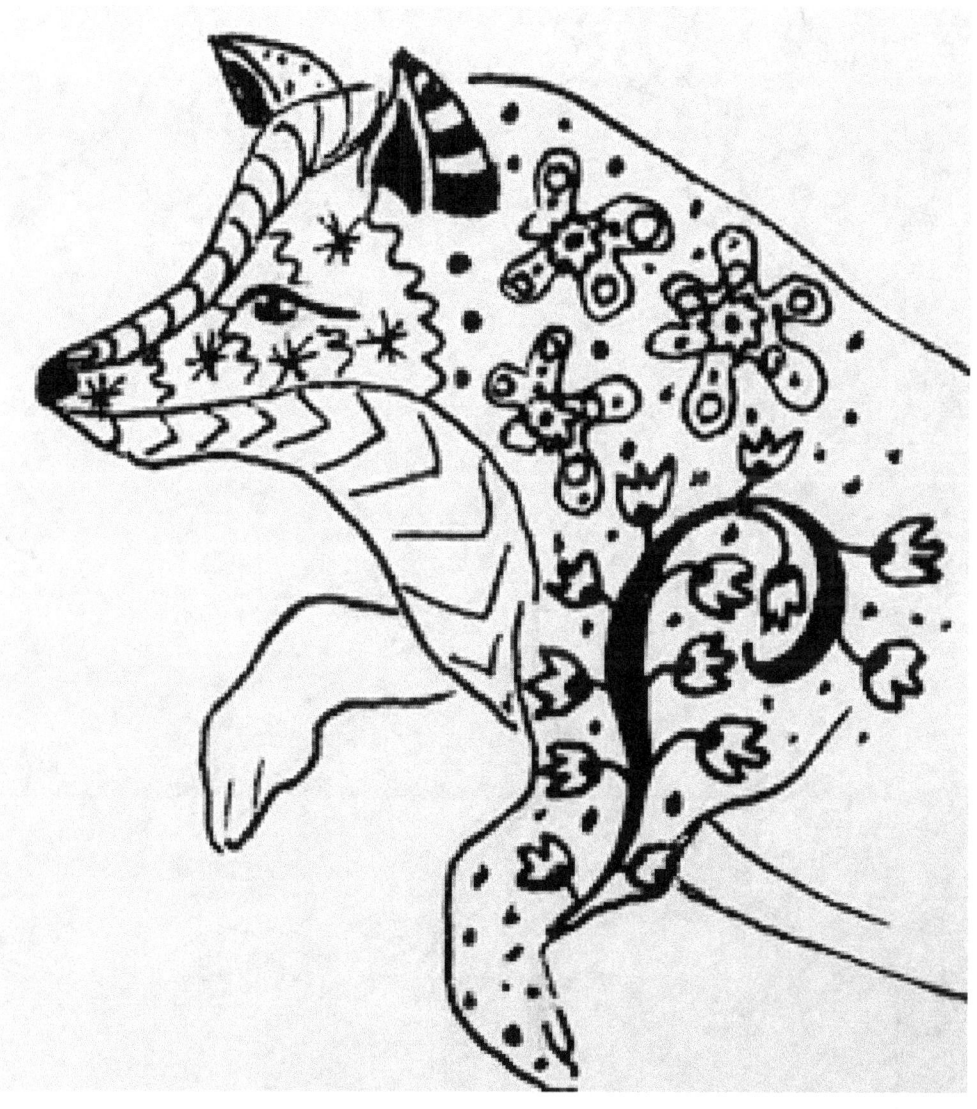

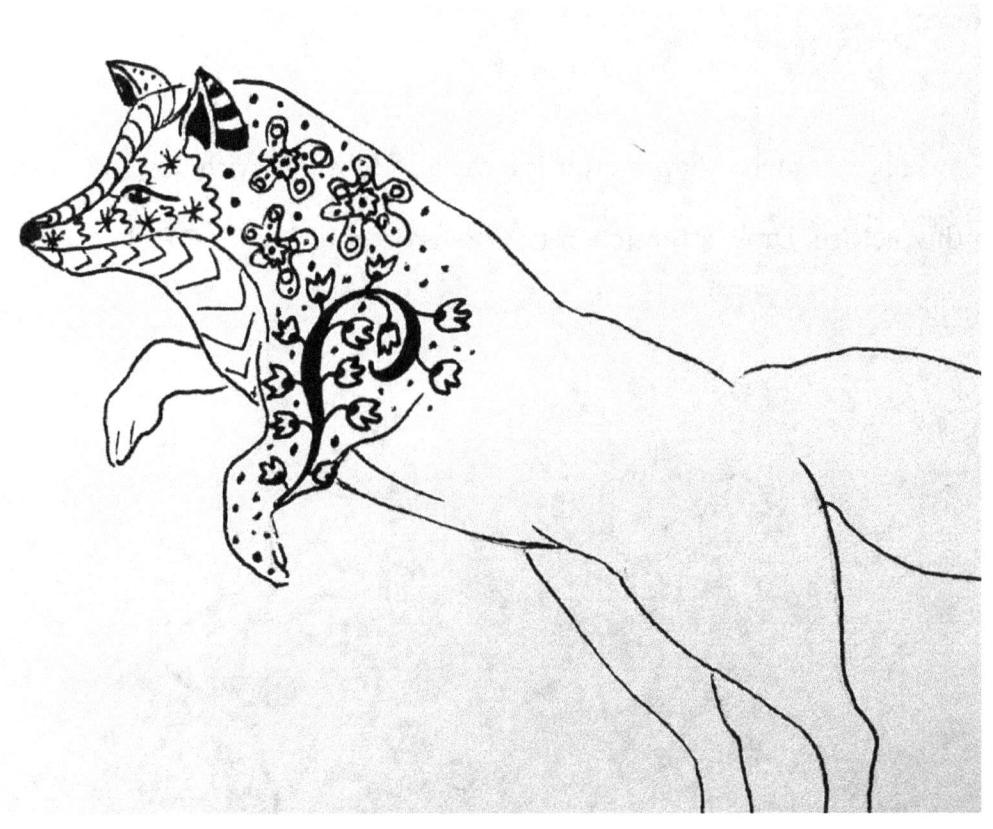

Step 4

Draw an arc in the posterior of her body and fill it with ink, followed by bullets enclosed in circles, V-shapes, and zigzag lines as shown in the picture.

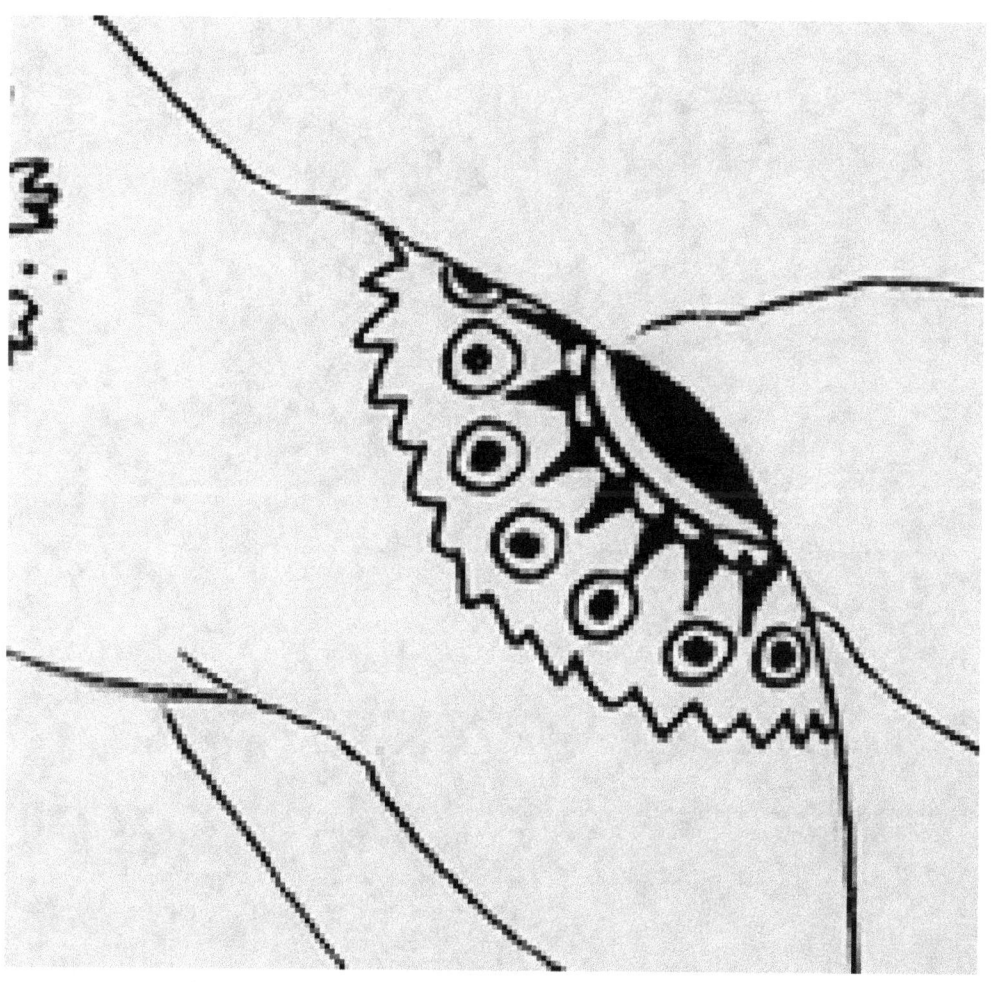

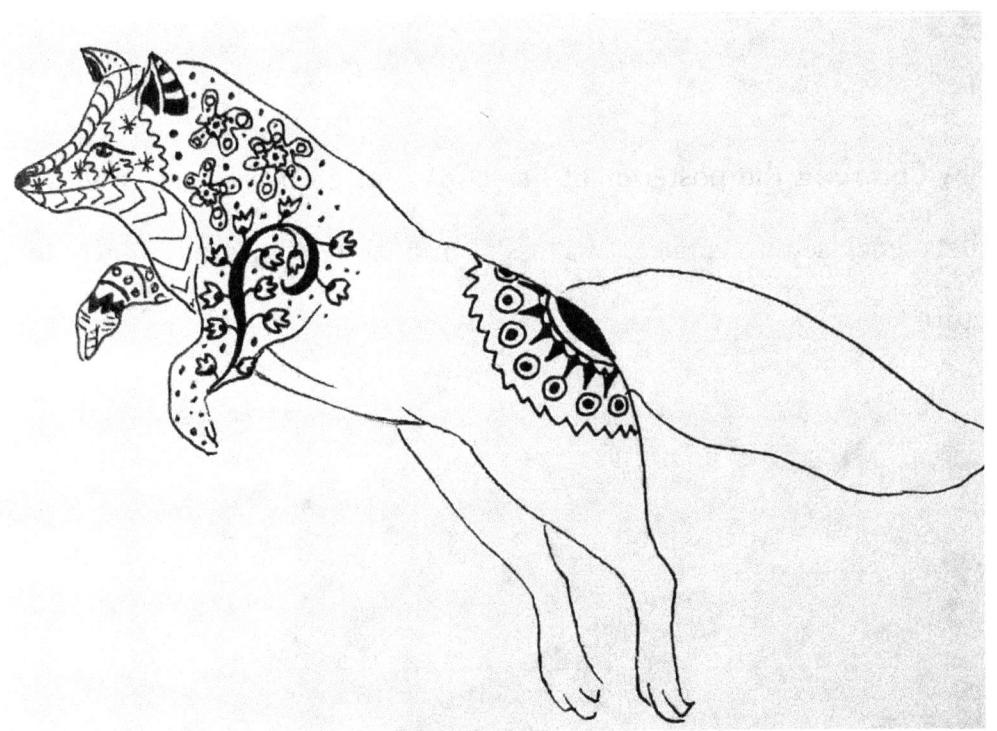

Step 5

Draw a few drop shapes in the body, emerging from the upper portion and lower portion of the body. notice that there are some spaces left in between the designs.

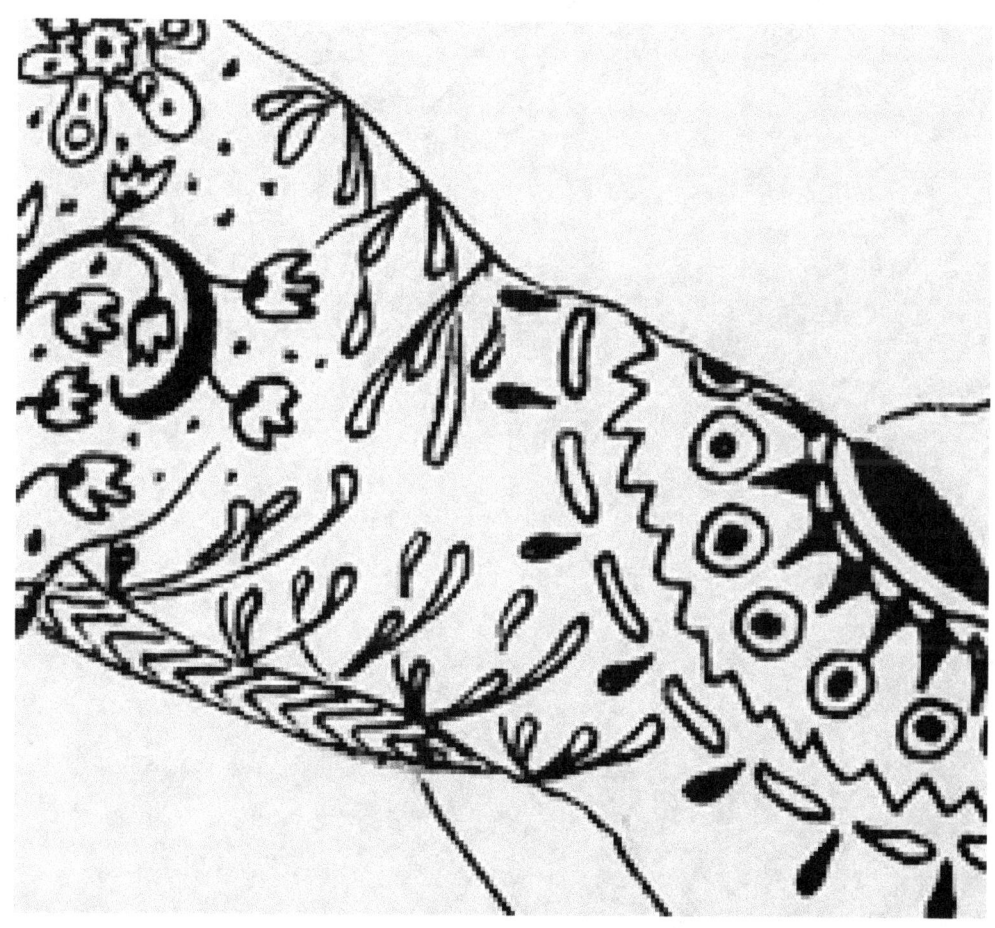

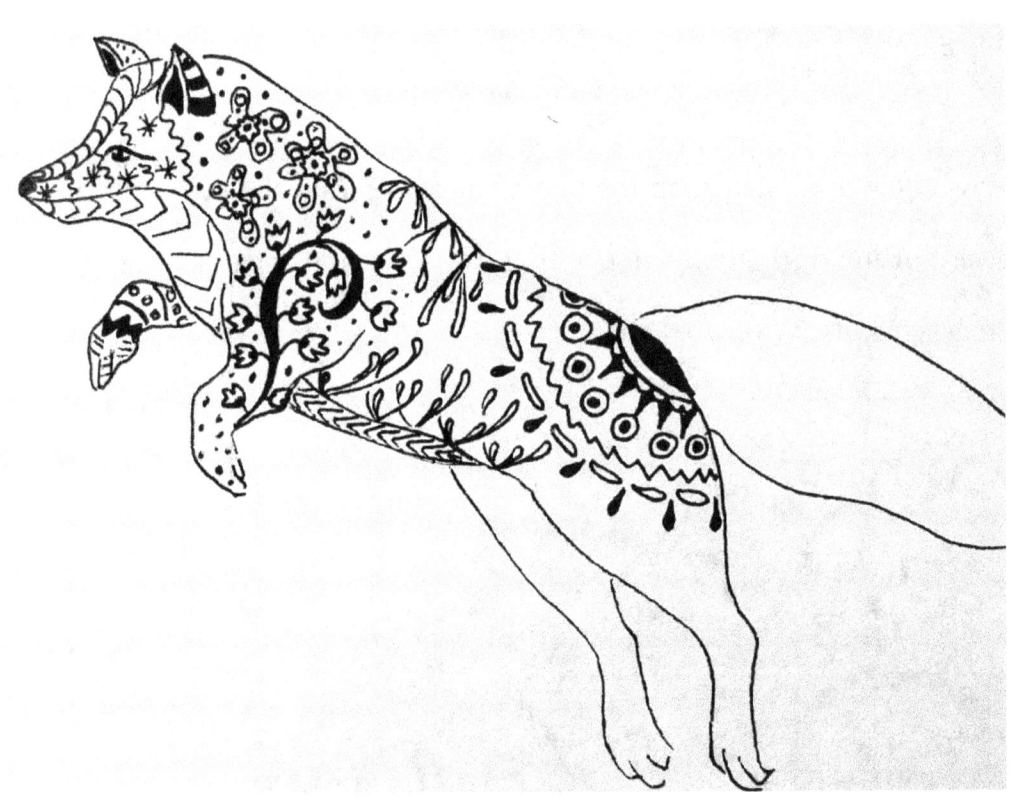

Step 6

Draw flowers in the tail and enclose them in circles. Draw scallops around the circles. Draw a few waves, *- shapes, and diagonal thick lines in the feet.

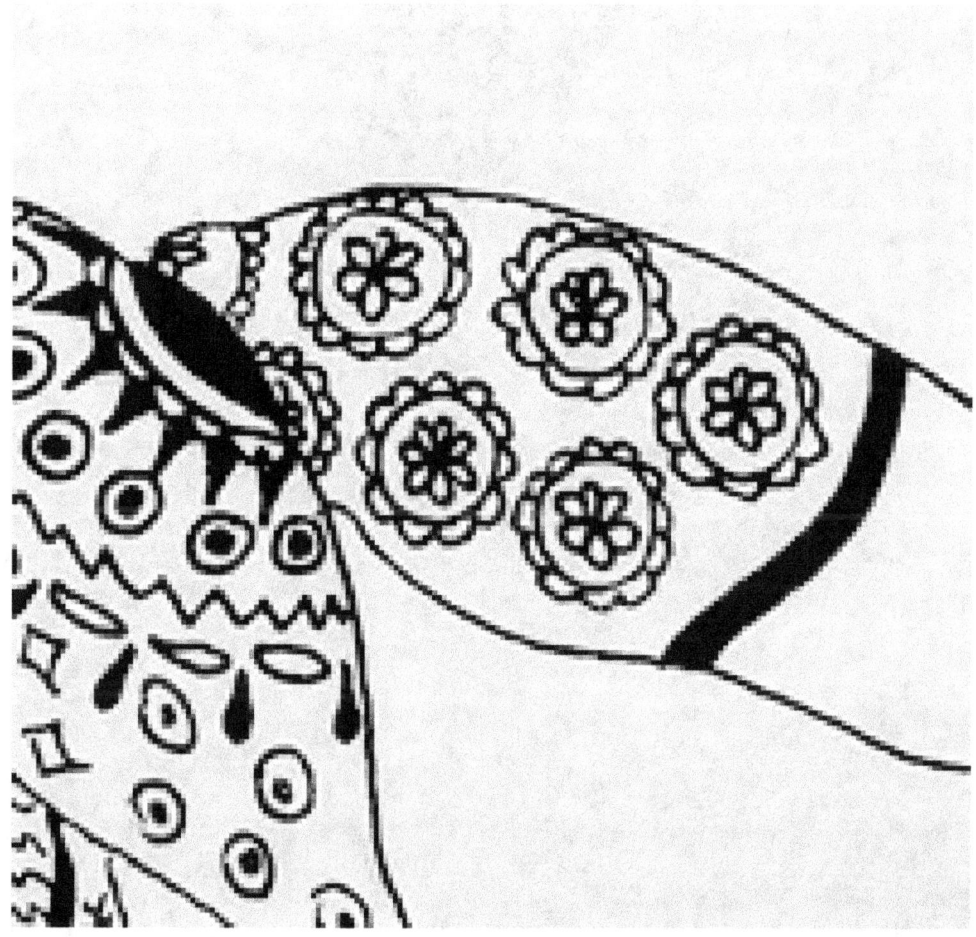

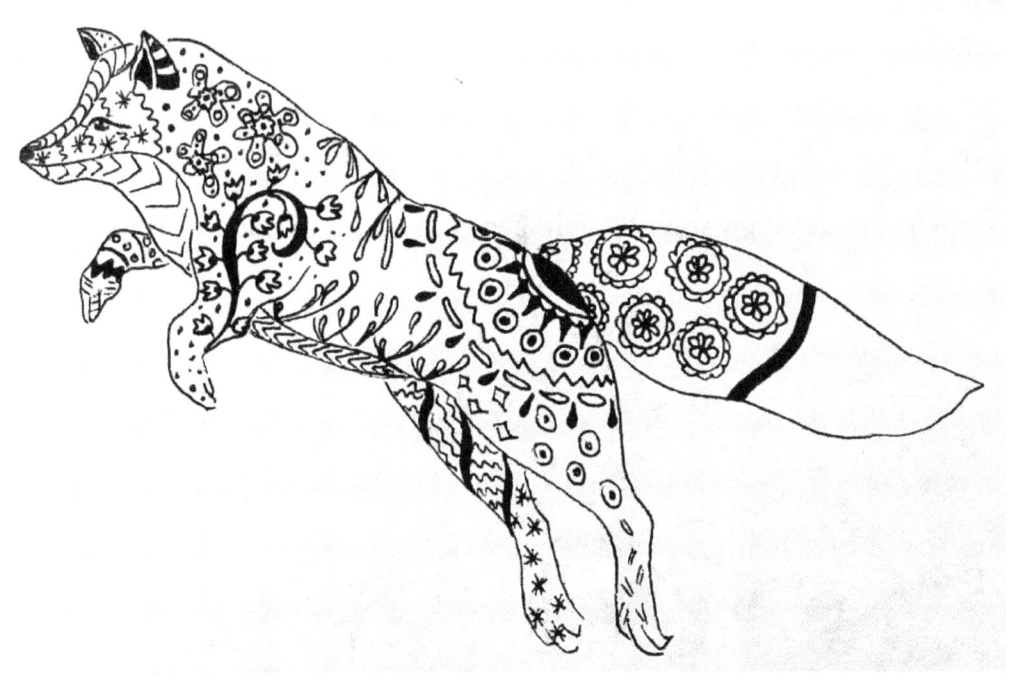

Step 7

Fill up the tail with designs as shown in the picture.

The doodle for this fix is complete.

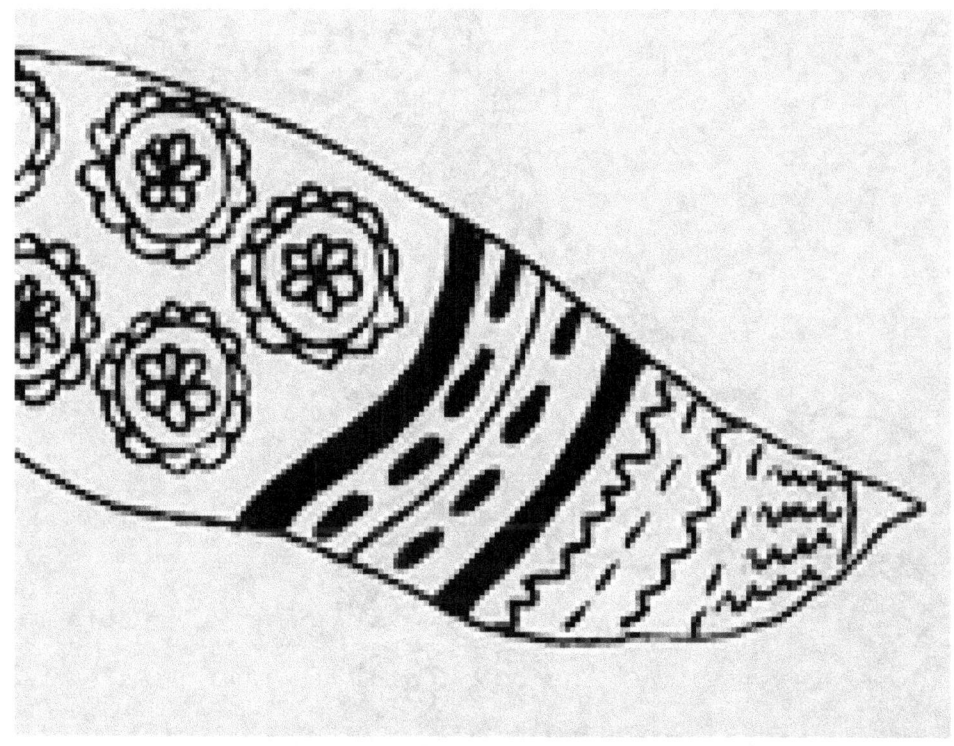

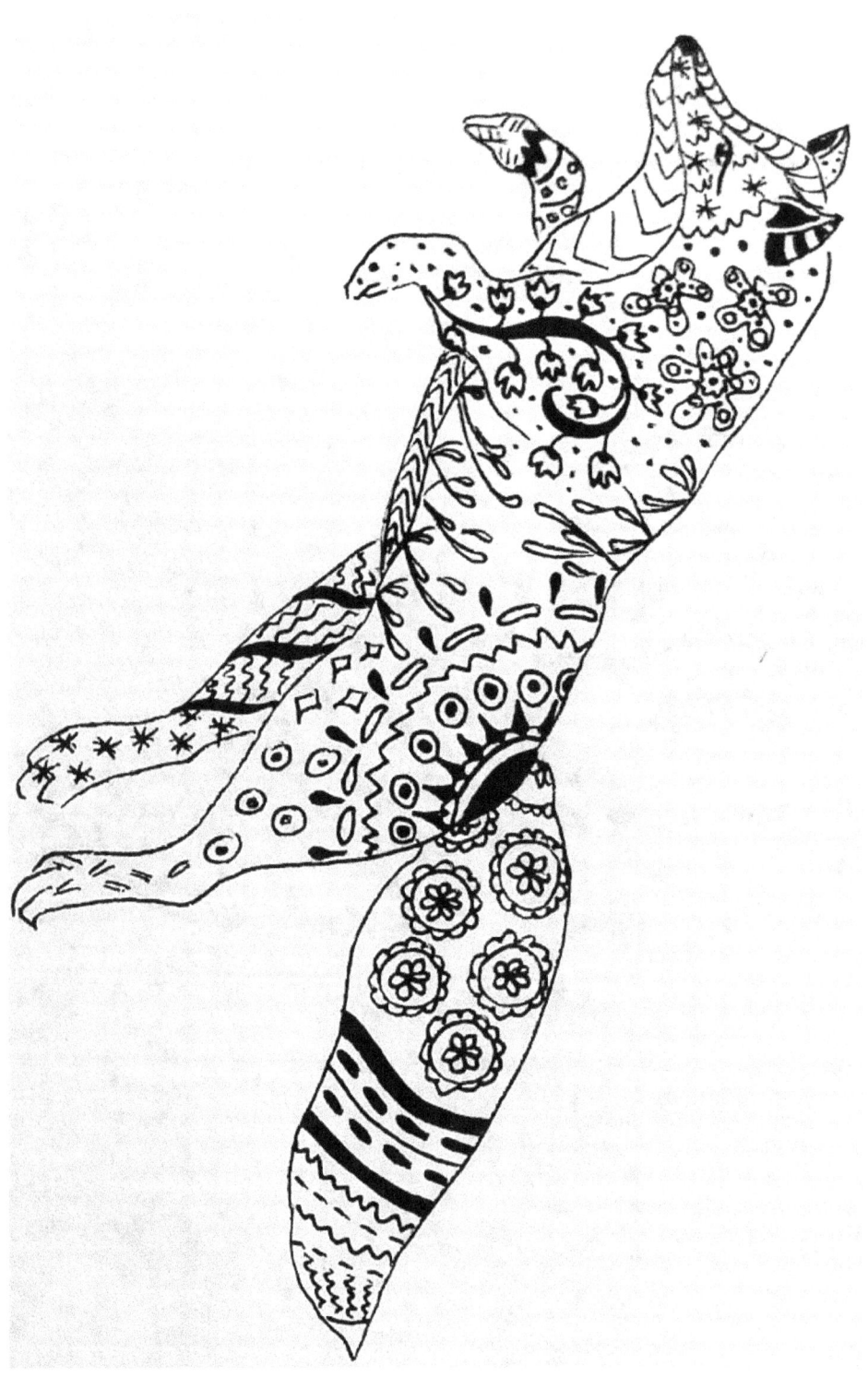

Chapter 6 The Penguin

Penguins are one of the most social species of birds in the world. They love humans and receive love in return. Mostly, they feed and swim in groups and the groups, known as rookeries, may be as large as thousands of penguins together.

Let us explore the doodle of a penguin.

Step 1

Draw the basic outline of a standing penguin.

Step 2

Finalize the outline with an ink pen.

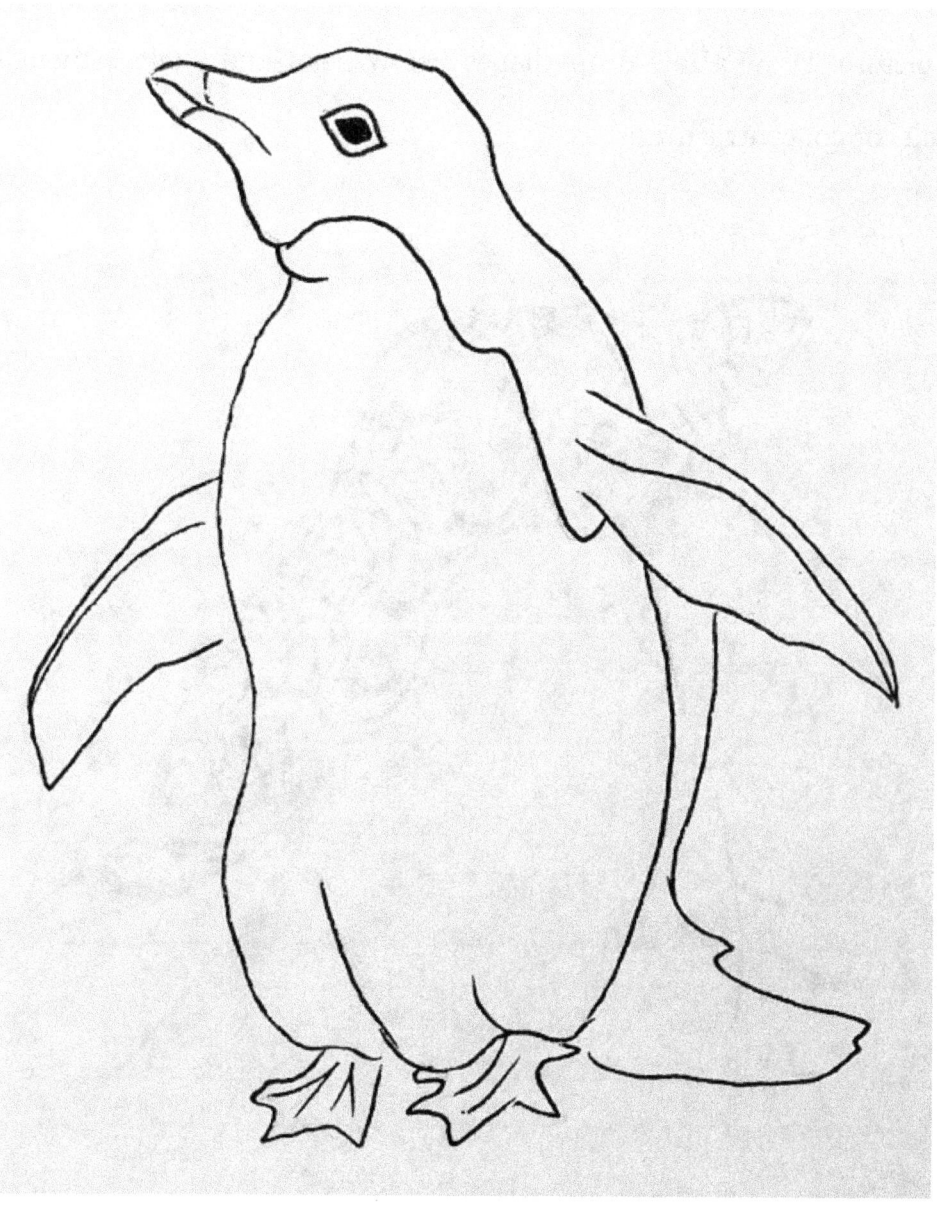

Step 3

Draw an arc on the topmost area of its head and fill it with ink. Draw a snail like creature below the arc. Fill up the head and beak with designs shown in the picture. Draw a few drop shapes below head and enclose them with parallel or concentric drops.

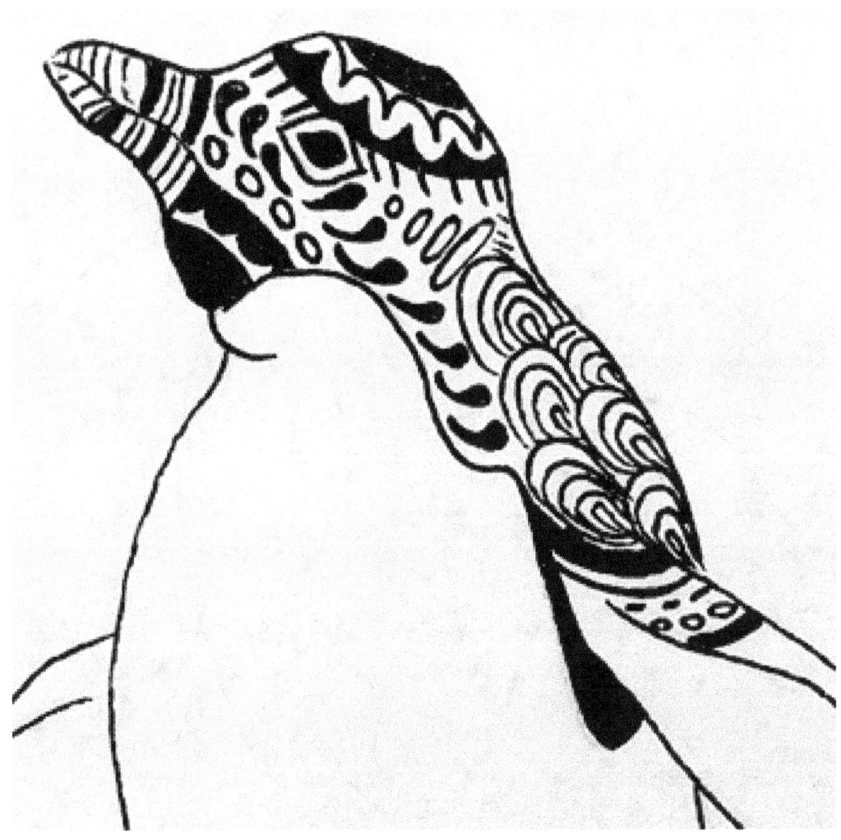

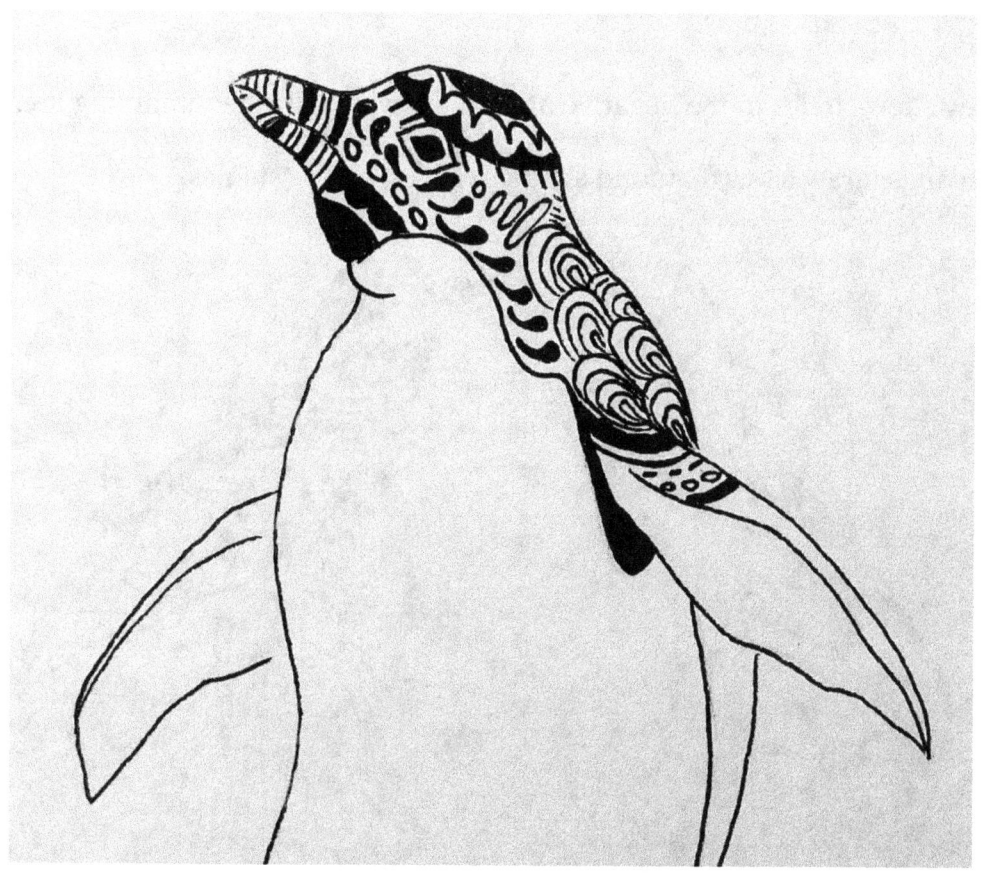

Step 4

Draw a few circles in the negative area of the wings. In the remaining area of the wings, draw a few diamond shapes, circles, and *- shapes.

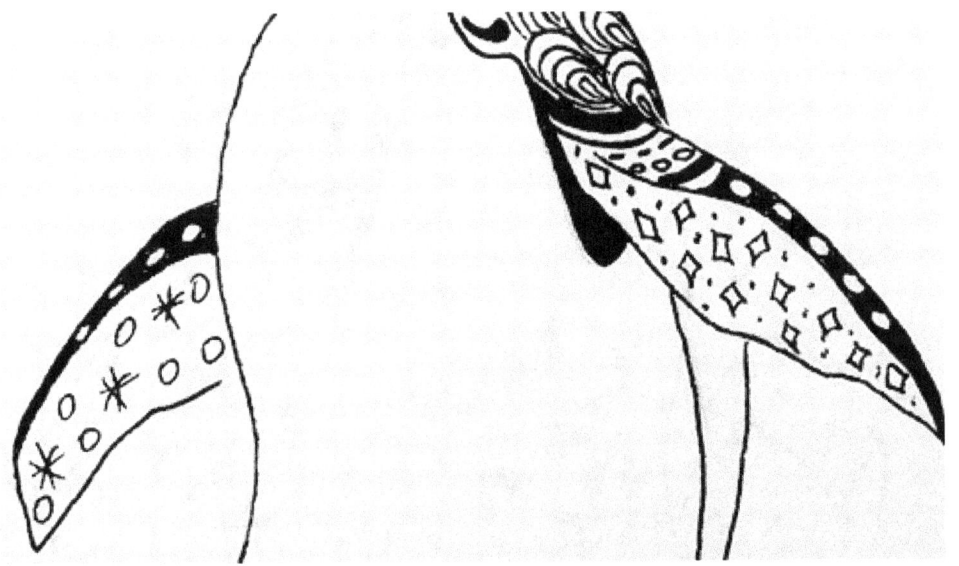

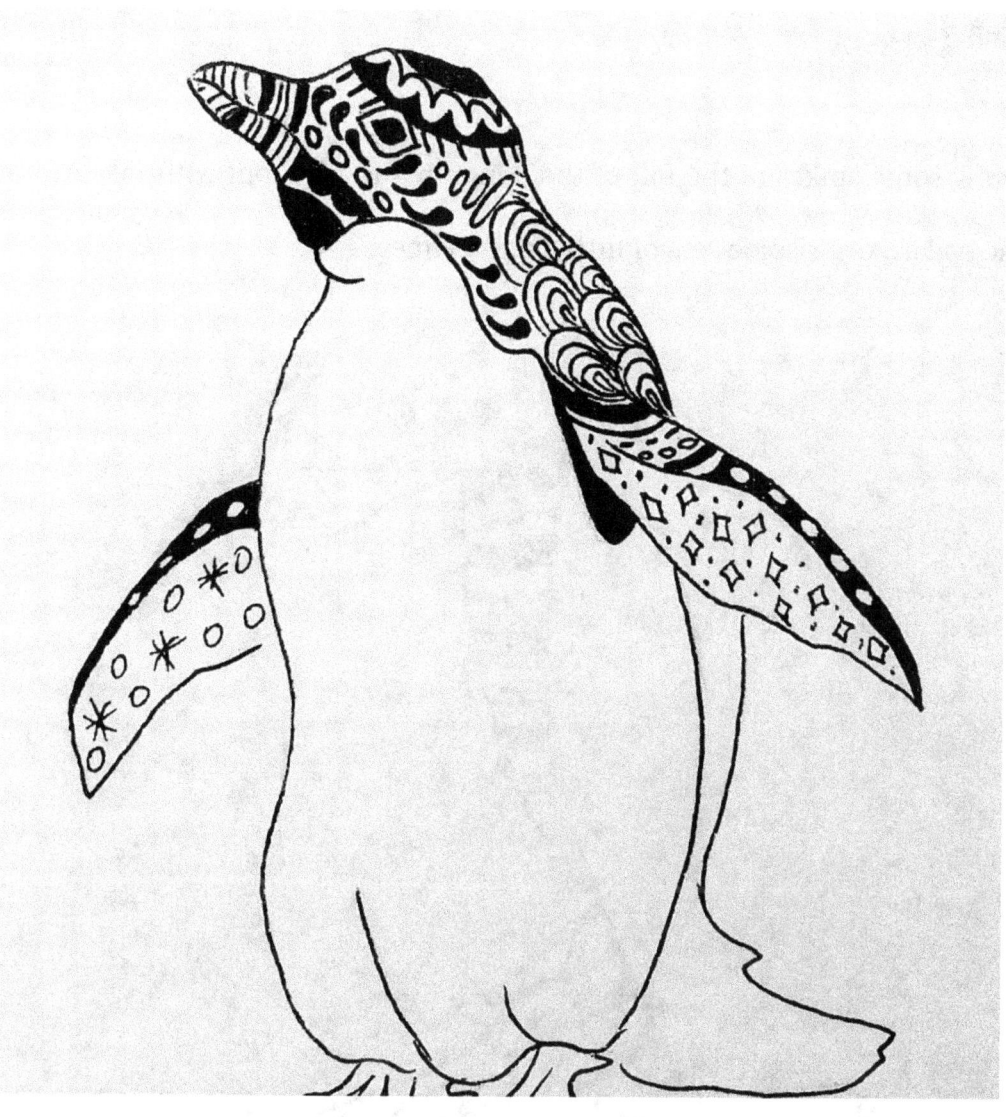

Step 5

Draw some spikes in the tail of the penguin and fill them with ink. Around the spikes, draw some sets of little parallel lines.

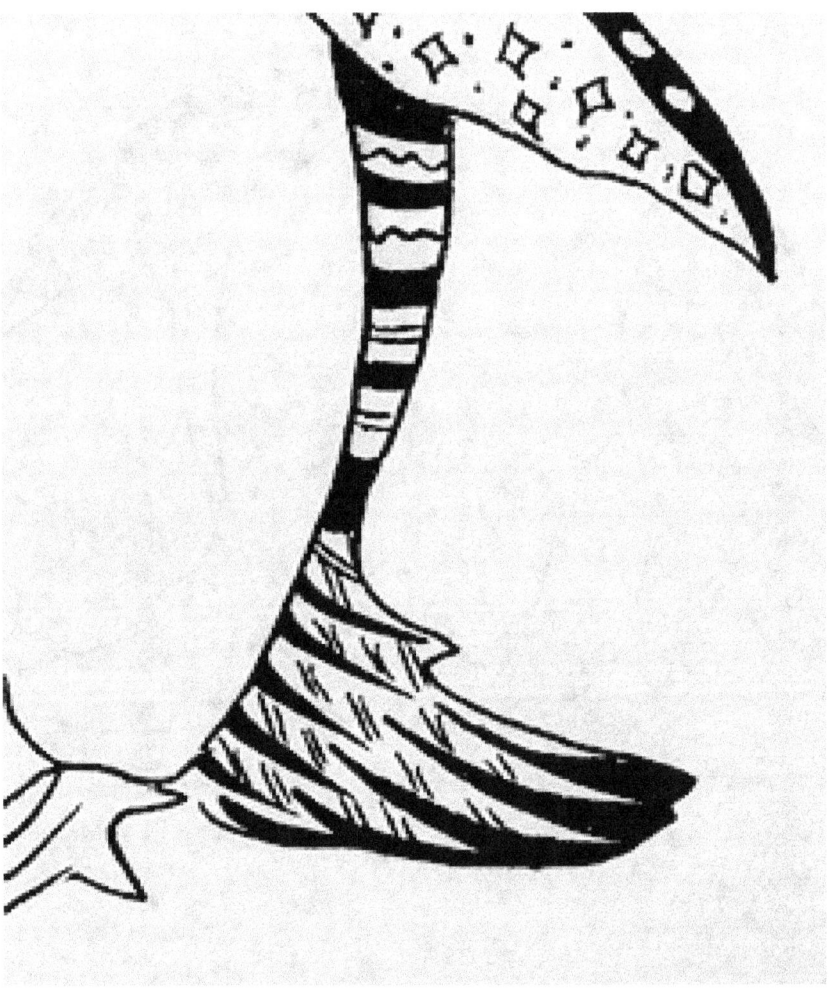

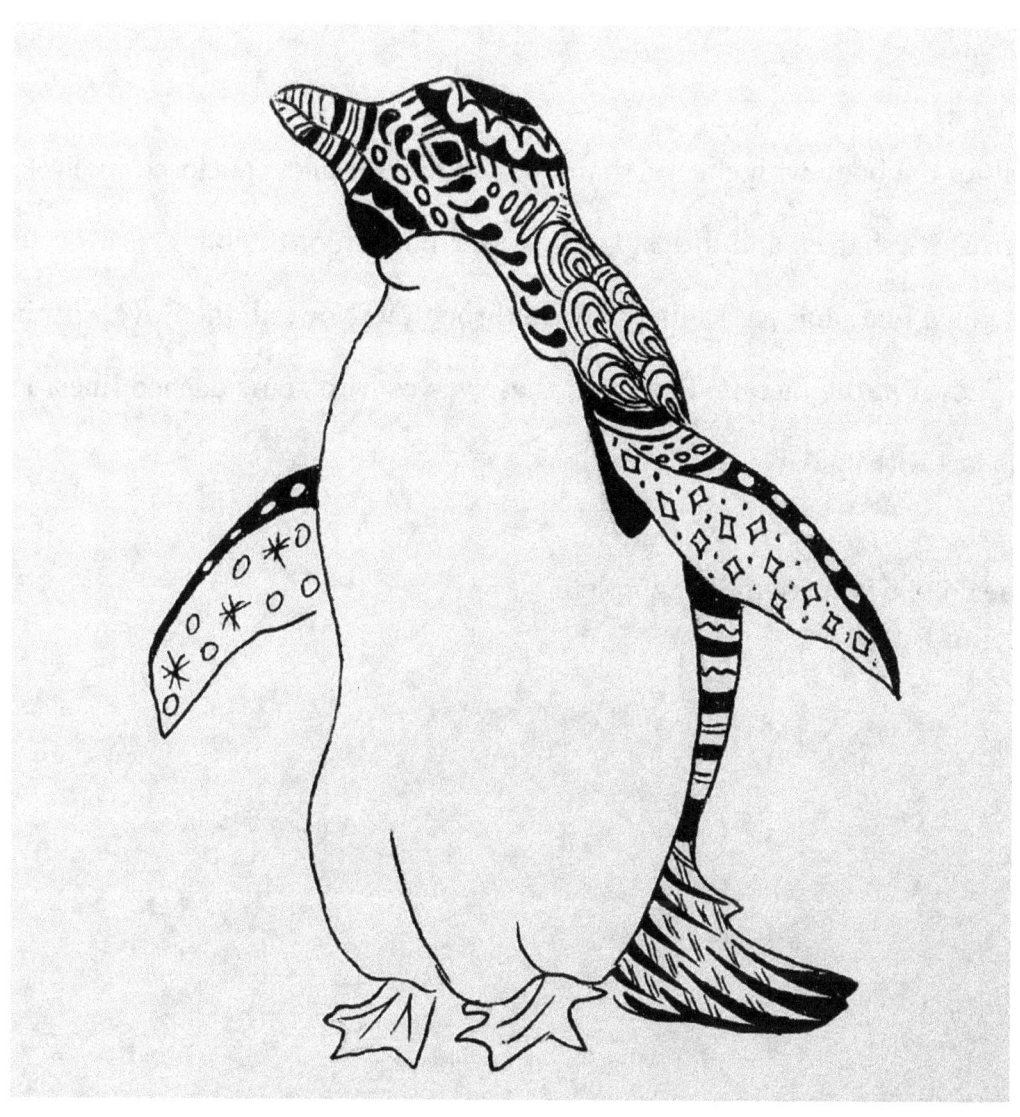

Step 6

Fill up the body with checks, diamonds, flowers, bullets enclosed in circles, swirls, X- shapes, and drops. In the lower portion of the body, draw a few diagonal lines and pass a line of wave through it. Now, fill the wave with ink as shown in the picture. Surround these waves with some dashed lines. Fill the feet with spider- web like designs.

The doodle for penguin is complete.

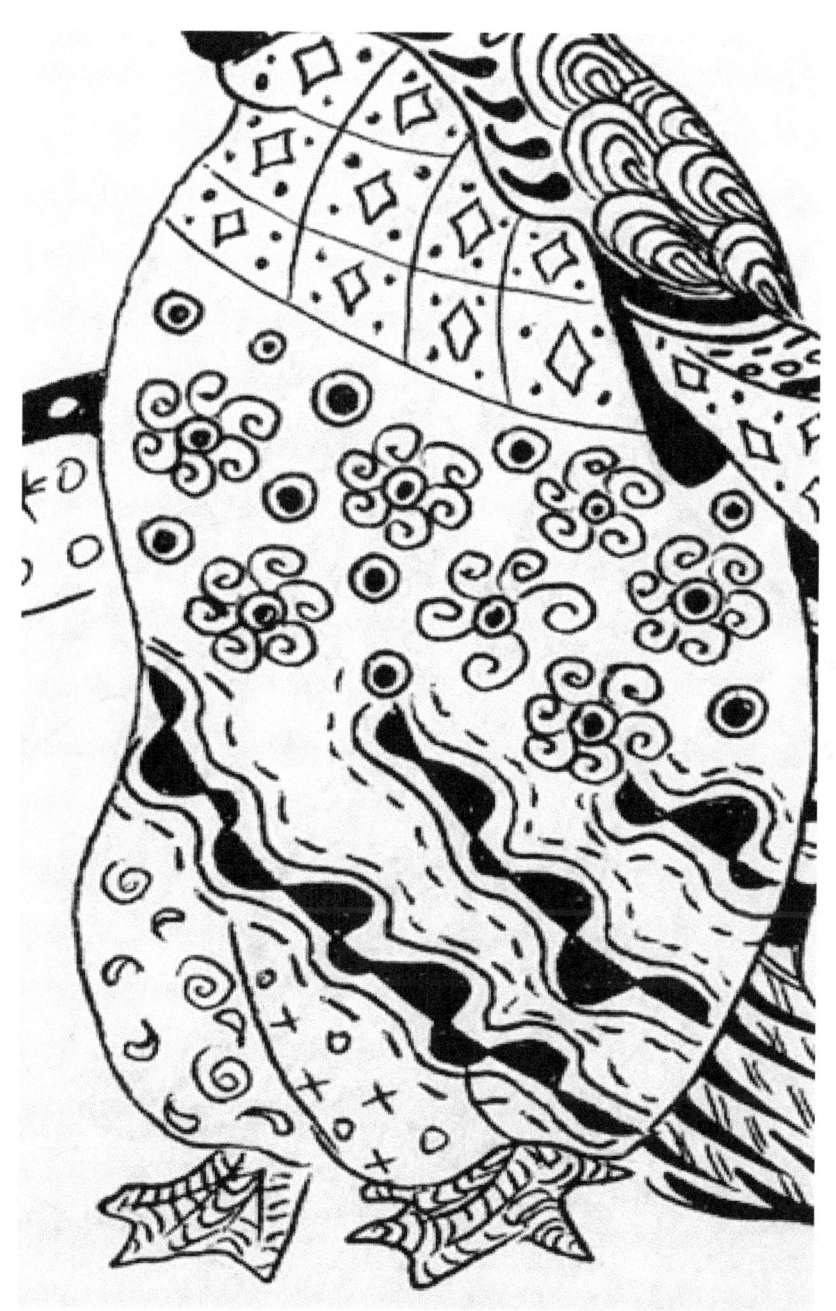

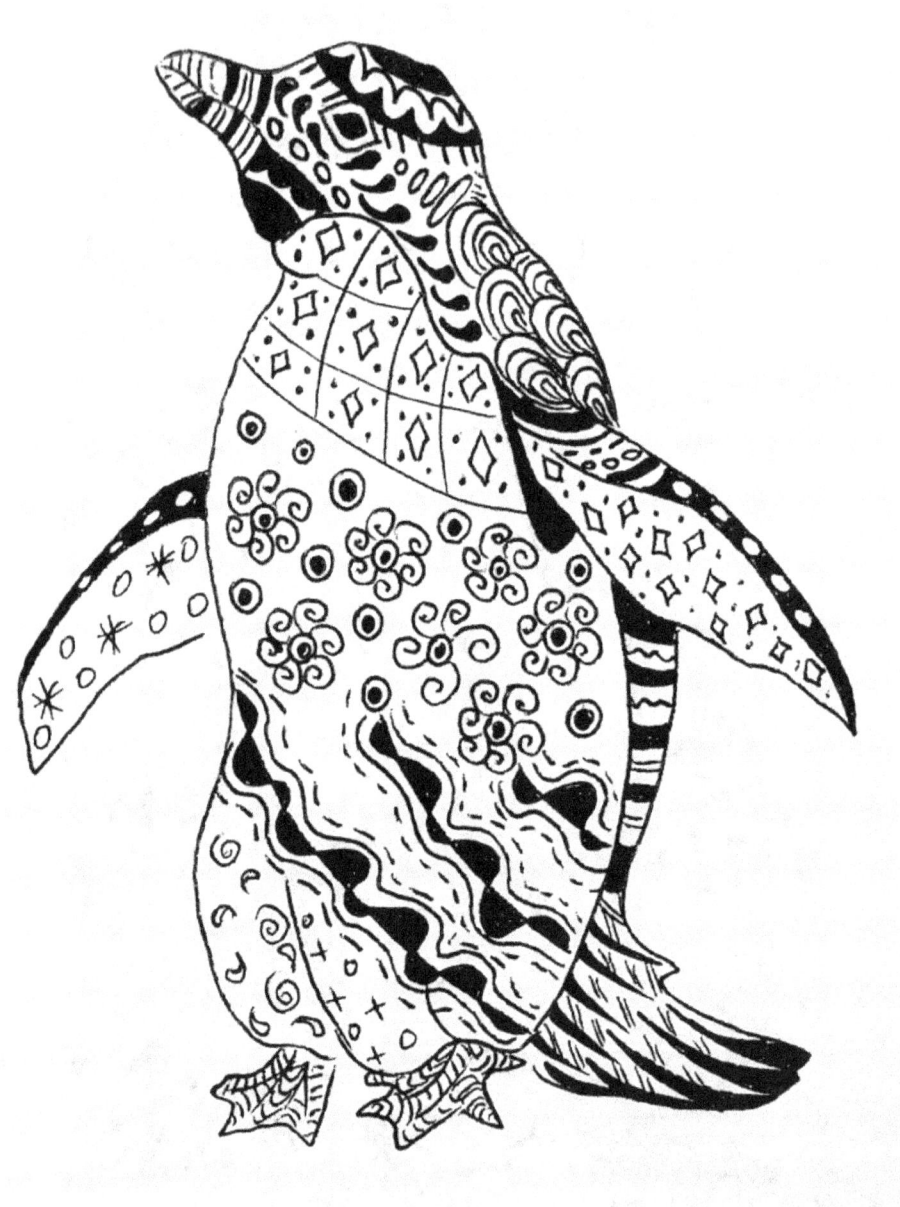

Conclusion

After reading **Doodle Art Drawing: Let your Imagination Doodle Amazing Things around you,** are you feeling a sense of confidence? We are sure you must be. Many people are scared of putting pen to paper and going through a book like this at least gives a sense of confidence to start doodling. Doodling is something anyone on earth can do. You do not have to possess inherent artistic skills to become a doodler.

If you have grown up watching people create beautiful paintings, and you have always wanted to create one, doodling is the first step to go. The basic tools needed for doodling are very easily available. You just have to make your mind up to start the process. If you feel any less motivated, you can find other ways of inspiration such as making friends in online doodling forums, finding pictures from Google, Pinterest, etc. If you have carefully gone through part one of this book, you must have read ways of getting inspired through various ways.

Doodling is not just a matter of one day or two; it is more like a way of life. You cannot just doodle one day and forget it the following day. You can adopt this lifestyle by carrying a small drawing book, a pen, and a pencil with you wherever you go. The basic things are not very heavy and do not take much space. If you keep the things with you all the time, you will find that there are many things around you wherever you go, which can be a source of motivation for you.

For instance, a sofa in an office is inspiring you and you are waiting for someone to meet. If you do not have your stuff with you, you will miss this chance of doodling in that office. If you have the things with you, at least you can give a basic outline of that sofa in your drawing book. You can refine it later when you have time.

Take little steps as these for doodling and you will find that time has made you an expert doodler.

Have a great time doodling!

Thank you!

Thank you for choosing our book, we hope you found it interesting and helpful.

If you liked the book, please give us a favor to write your review.

We would really appreciate this!

If you would like to have a bonus – **FREE BOOK**, please send the screenshot of your review to this e-mail: **lucy.artbooks@gmail.com** and we will send you a **FREE BOOK** in PDF as a **GIFT**!**

Hope to see you in our future books and good luck in your drawing experience!

**** in the e-mail subject please mention the name of the book you reviewed and the author.**

www.ingramcontent.com/pod-product-compliance
Lightning Source LLC
Chambersburg PA
CBHW081204180526

45170CB00006B/2206